Most people don't want to acknowledge that everything they know is a falsehood. *Who would?* ... Of course we're going to be reluctant to believe narratives that challenge our whole identity. It means realizing that we have been acting out of ignorance and through our subconscious minds our whole lives. Acknowledging this truth *is* uncomfortable.

brazen

More praise for *Women Don't Owe You Pretty:*

"An incredible mouthpiece for modern intersectional feminism...a rallying call for women of her generation to feel f****** fabulous about themselves."
– *Glamour*

"A deep dive into subjects like self-love, empowerment and patriarchy [that] aims to appeal to women (and men!) in all stages of their feminist journeys."
– *Wonderland*

"An accessible exploration of feminism built around the historic and modern expectations of women."
– *Livingetc*

"[A] call-to-arms tome."
– *Irish Tatler*

THE SMALL EDITION

WOMEN DON'T OWE YOU PRETTY

FLORENCE GIVEN

brazen

First published in Great Britain in 2021
by Brazen, an imprint of
Octopus Publishing Group Ltd
Carmelite House
50 Victoria Embankment
London EC4Y 0DZ
www.octopusbooks.co.uk

An Hachette UK Company
www.hachette.co.uk

ISBN 978-1-91424-034-8

A CIP catalogue record for
this book is available from
the British Library.

Printed and bound in Great Britain

10 9 8 7 6 5 4 3 2 1

This FSC® label means that materials used for
the product have been responsibly sourced

MIX
Paper from
responsible sources
FSC® C104740
www.fsc.org

CONTENTS

A NOTE ON THE SMALL EDITION

Since *Women Don't Owe You Pretty* first published, people (mostly women) have told me that the book has given them permission to want more for themselves, to feel less guilty about needing more. It has given them the ability to label and give language to feelings they've had about sex, relationships, their gender, sexuality and their bodies.

I'm honoured to be a part of this conversation and love hearing readers' feedback on how the book has shaped their feminist journey. But, there was one particular reader message that I haven't been able to shake. It was from a woman who had read my book over and over but told me that she was still crying about a boy who didn't reciprocate her feelings. She felt as though she had failed as a feminist because she was *"still"* heartbroken.

I saw myself in her pain and her shame, and I believe that there are lots of us who feel as though we have to fight heartbreak. I too have wrestled with wanting to feel like a Bad Bitch, yet found myself in my Uber on the way home after a shitty night out unable to stop crying over someone who didn't want me...from two years ago.

It's as if, by admitting that our hearts can be broken, we worry we're admitting that we do actually possess the imposed fragility we've fought for centuries to overcome in the name of equality. The same "fragility" that's attached to femininity, that has prevented the world from taking us seriously, has marginalized

and controlled us, has stripped us of our value and has stopped us from being elected as leaders.

We have collectively shamed heartbreak away from feminist conversation and dialogue. Myself included. Women have been told for so long that all we care about is romance. So we feel we're doing a disservice to feminism by talking about how much we enjoy, desire and long for it, and by admitting that we do experience heartbreak when we want something that doesn't want us back.

We bury our hurt and play down our desire for romance. But in concealing our desires this way, are we not just emanating toxic masculinity? Hiding our experiences of heartbreak from one another to seem more "feminist" – isn't that just what men do with other men? Block their vulnerability? We don't need to imitate how the patriarchy have traditionally acted to stay in power. Instead, we should create new ways of finding power, based on our ability to express ourselves and be vulnerable, finding empowerment from a radical openness.

Feminism has to allow people to live their lives without shame in a way that feels authentic to the individual in accordance with their values and desires, no matter how closely or far away from patriarchal values those desires dwell. Because any movement, person or organization that requires an individual to silence a part of themselves in order to participate will destroy their soul over time.

Heartbreak deserves a place in the conversation, and I want to honour it with a new chapter in this small edition of *Women Don't Owe You Pretty*.

FEMINISM IS GOING TO RUIN YOUR LIFE
(IN THE BEST WAY POSSIBLE)

"A comfort zone is a beautiful place, but nothing ever grows there."
– Unknown

My journey into feminism was exhausting.

I lost friends, cried in nightclub toilets because the normalization of groping repulsed me to my core, *screamed* in the faces of men who cat-called me, and fell out with my parents on multiple occasions.

Very on-brand for me.

Very dramatic.

But I had to do this in order to grow. I had to (and still do, regularly) go through a period of sitting in toxic bullshit, abandoning old versions of myself, shedding skins and experiencing this uncomfortable transition to be the person I am today – feeling confident enough in myself and my voice to write this book, speak my mind and vocalize my experiences.

Growth can feel isolating. Everything you thought you knew about yourself and the world shifts right before your eyes. You'll start to notice unhealthy and toxic qualities in your friends, as well as yourself. You'll stop enjoying your once-favourite movies when

you realize they portray women as nothing more than a feast for male eyes and desires. The lyrics to your favourite Rolling Stones song start to ring a little problematic, and you'll be disgusted to discover that sexism, racism, ableism and transphobia exist in almost every environment, including the depths of your own subconscious mind. A shift in perspective has the power to flip the world as you know it upside down. But wouldn't you rather see the world clearly, than walk through life oblivious to all that you are complicit in and enabling?

Don't be a passenger in your own life.

Having your world turned upside down and experiencing temporary discomfort is minor in comparison to the suffering you would have endured *and* inflicted onto others over the course of your life if you left these things unchecked. *Temporary discomfort is an investment in your future self.* Accept a small and uncomfortable transition now, for a lifetime of growth and self-development.

Feminism and self-discovery will uproot your entire life, but it's going to be worth it. I promise.

YOU WON'T BE ABLE TO ENJOY THINGS ANYMORE

Enter feminism, the world of hating everything.

Just kidding! *Kind of.*

But baby once those goggles are off there's no going back. You're going to see the misogyny, racism and double standards in absolutely *everything*:

- One minute "chick flicks" are your favourite movies, the next they're the stereotype-perpetuating garbage that you blame for making you crave male validation.
- Past sexual experiences that left you feeling uncomfortable

might now actually be reframed as assault or rape, as you learn to understand more clearly the definition of consent.

- Yes, you'll find yourself enraged over the slightest things. Right down to how much space men take up on public transport with their legs, and how you so instinctively cross yours.
- Yes, you might realize how your own behaviour changes when you interact with men, and how there's an innate urge for you to be polite, desirable and palatable.
- And yes, your eyes are going to open up to the fuckery in our society and your *own* behaviour that was so normalized. You might feel repulsed at yourself for never spotting it in the first place.

But guilt is an unproductive emotion. Feeling guilty for past mistakes and behaviours does nothing for you or the people you harmed, unless it is accompanied by changed behaviour. What matters is that you're aware now, you're waking up, and the actions you take moving forwards are how you stop perpetuating further harm.

YOU WILL LOSE FRIENDS

With growth comes discomfort, this is inevitable. You have to be willing to outgrow your peers, your friends, and even your family, if you're going to live a fulfilled life on your own terms, break cycles and lead a new path. Hopefully, they'll grow with you or support you through your journey. But worrying about what others think when you're growing isn't your priority. Right now, just focus on *growing*.

This is probably the toughest thing you will face as you become more socially, politically and *self*-aware. As you outgrow the people in your life and embark on your journey of self-

development, you'll see sides of them that you never did before. You might even feel guilty for outgrowing them and believe them when they tell you that you've "taken it too far" or that you're being "too sensitive". But remember that anyone who tells you you're "too" *anything* is using the word because they are threatened by your capacity to grow, evolve and express your emotions. They want you to stay down there, with them – emotionally and morally stunted. You are a mirror reflecting back to them the parts of themselves that they know they're lacking. While this explains their behaviour, it does not excuse it.

People who are emotionally secure and have a strong sense of self won't feel intimidated by your need to express the emotional responses you feel. Those who do are lacking, and you are abundant. Never apologize for this. Being empathic and able to truly *feel* so intensely is a gift, a talent, and something that people strive for. You do not have to shrink yourself down to make others feel better about themselves.

Stop surrounding yourself with people who make you question your worth, and fill your life instead with people who choose to *remind* you of it – while simultaneously holding you accountable when you mess up. *Both these things are acts of love.*

If I listened to every person who told me I've "taken my feminism too far" or believed every person who told me "not everything's about race/gender/sexuality", I'd still be stuck in my old ways of ignorance and stagnancy, which is *exactly* the type of person the racist patriarchy relies on to keep these systems of oppression alive and thriving. Don't leave conversations about politics to "the grown-ups". *That's what the grown-ups want.*

Patriarchy hates progressive conversations and disruptive people because it's a parasite that feeds on *silence and fear* – just as rape culture relies on the silencing of its victims. This is why the #MeToo movement founded by Tarana Burke was so instrumental in raising awareness and challenging the normalization of sexual assault. When people shut you down for "speaking up", it's because they want the status quo to be maintained. It's a tactic as old as time. Stay headstrong. Keep going.

Most people don't want to acknowledge that everything they know is a falsehood. *Who would?* The whole *point* of evolving is that it's an uncomfortable (but necessary) transition. Of course we're going to be reluctant to believe narratives that challenge our whole identity. It means realizing that we have been acting out of ignorance and through our subconscious minds our whole lives. Acknowledging this truth *is* uncomfortable. Knowing you have been unintentionally causing harm and benefitting from unfair systems *is* uncomfortable. But think about how uncomfortable it must be existing on the flip side of that privilege.

Imagine your identity as a woven piece of fabric – from birth your entire identity has been worked into the piece of fabric and makes you who you are today. Threads upon threads make up the unique person you are, just like your DNA. Who you were told to be, who you were told to trust, how you were taught to give and receive love and how you respond to certain situations, all of these factors make up *your* reality as you know it. Now imagine someone coming along and saying something that challenges and unravels the threads of your identity, and how that might make you feel. This is where people can become defensive. Rewiring our toxic

and self-destructive patterns isn't supposed to be comfortable, but the more open-minded and aware you are to the fact that we all perceive and live *different realities*, because our fabrics have been woven differently, the easier it becomes to grow, empathize, evolve (and reweave your fabric) with ease and self-awareness.

STOP JUDGING OTHERS SO HARSHLY FOR THINGS YOU RECENTLY STOPPED DOING YOURSELF

I want to make it clear that people who are at the receiving end of abuse, whether directly from an individual person or by a system of oppression such as racism, don't owe anyone their forgiveness. Rape survivors don't owe their rapist "second chances" because "people make mistakes". People of colour do not owe white people forgiveness. Women do not owe men forgiveness. It's up to them. No one owes their abuser/oppressor *shit*.

I'm talking here about unintentional slip-ups that we ourselves make. Sometimes on our journey of self-development, to cope with the realization that we have perpetuated toxic behaviours and tendencies, we find ourselves taking it out on other people to assuage the guilt we feel about our newly discovered shortcomings. For example, it's only over recent years that I've come to learn how loaded the term "bitch" is when used as an insult. Once I realized how often I'd used this to describe women (who were actually just assertive, and reminded me of my *own* lack of boundaries and *my* inability to say "no"), I'd jump down the throat of anyone around me who used the term "bitch", instead of just informing them the way that I was once informed.

Everyone should be held accountable for their actions, but we still need to extend the same forgiveness and room to grow

that was afforded to us when we were still learning. Which, by the way, we still are. Every one of us – every day. We are never done learning. When you decide to stop supporting someone for making a mistake or calling them out to make yourself feel better, it isn't an act of holding someone accountable, it's an act of self-righteousness. It's also ineffective and counter-productive, because no one learns anything and the problem doesn't actually get solved. It just makes *you* feel better about yourself and your own shortcomings.

It's important to acknowledge red flags and abusive behaviours before they become a bigger problem, but people make mistakes. Do you have a friend who's really bad at communicating? Tell them. Your mum making outdated comments about women's bodies, your racist grandma, your friends shaming other women for casual sex, your boyfriend insisting on doing all the "man things" and making jokes about women in the kitchen (just dump him), white girls wearing cornrows, calling them "boxer braids" and singing *that* word in rap songs, your feminist BFF who "doesn't agree" with sex-workers – call them out. Inform them. Their bullshit is their problem, not yours. *They* are the ones who should feel the pressure and guilt to change, not you.

If you have the capacity, you can explain *why* as white people we can't say *that* word (yes, even though Kanye sings it), *how* jokes about "women in the kitchen" perpetuate sexism. Explain to your mum the standards women's bodies are held to in comparison with men's, how we are expected to show up a certain way in this world, and who are we to blame people for conforming under systems of oppression?

Remind your grandma that this isn't the 1960s and you can't say shit like that anymore. In fact, that shit was never okay. Tell your BFF that sex workers are *not* the enemy of progress, that they are in fact exploiting the system built to oppress them, and that this alone is iconic as fuck.

It's a different story when someone is repetitively causing harm. Some people just don't want to change. But you can still be a no-bullshit-taking zero-tolerance person when it comes to sexist, racist, transphobic, disablist, homophobic bullshit, while also allowing room for people to prove to you that they can grow, learn from mistakes and bounce back with changed behaviour – *just like you did.*

It's difficult when someone you love is saying something wrong and you don't want to correct them in case you come off as too "political" or "sensitive". But these are *exactly* the discussions you need to be having to change the world.

Some people go their entire lives without even questioning their identity, attempting to deconstruct patterns or end cycles of inherited trauma, because they're too focused on *surviving*. It's easier to live by the narrative that has been supplied since birth because they don't have time to think about evolving. Having time to unpack and evaluate is in itself a privilege! Having access to the internet and so many diverse perspectives has amplified the voices of people who are marginalized, and has an enormous part to play in how we're all a lot more socially aware than older generations and other societies. So be careful to remember that not everyone has the capacity, time and resources available to embark on this journey. Having this access is very much a class privilege. It's important to

share these resources when we have access to them.

This journey is going to be long and hard. It will tie knots in your stomach as you visit the dark corners of your mind and discover you've held life-long beliefs about yourself and other people you weren't even aware of. Whenever I have a self-discovery breakthrough, I break *out*. Literally. My skin breaks out in spots – but I think those spots are beautiful. Each one of them represents my toxic behaviours, trauma, unhealthy coping mechanisms and long-held beliefs surfacing after *long* processing, ready to exit my body. It's a sign that I'm shedding another skin, preparing for my glow-up. Then off we go again...

Feminism is going to ruin your life, but in the best way.

No more watching your subconscious drive your life around for you while you sit in the passenger seat as it unfolds. You're going to take the wheel and drive it your damn self. Because silence and complacency in situations of injustice make you complicit in the violence.

Speak up.

Say something.

Your words have the power to change the world.

WOMEN DON'T OWE YOU PRETTY. BUT...

We live in a patriarchal society which prioritizes our desirability above anything and everything else. Which means that...Life is easier when we dress up. Life is easier when we shave. Life is easier when we wear make-up to work. Life is easier when we have made a visible "effort" with our appearance.Life is easier when we reflect society's idea of beauty. *Full stop.*

We are expected to show up and perform to expectations in order to be seen, and we know how to make our life easier if we apply the rules the patriarchy has set out for us. Look at where marginalized identities intersect with being a woman – trans women are still expected by society at large to perform this type of femininity to pass as a "real woman" (there's no such thing), and women of colour are expected by society to perform "prettiness" to a further degree, in a world where whiteness has been positioned as the epitome of beauty and "femininity". Historically there has been little representation of marginalized identities in the media and even when there is, it's often a stereotypical, harmful portrayal, constructing these identities as inferior to the default of whiteness, thinness and heterosexuality.

DESIRABILITY POLITICS – *AKA* "PRETTY PRIVILEGE"
Shaming other women for caring about their appearance is

just another form of internalized misogyny, and an inability to see how race, class, sexuality and desirability all affect the way you're perceived in the world. In a world that prioritizes looks over everything else in women, and affords you undeserved privileges once you reflect its ideal standards of beauty, who are we to judge people who pay for aesthetic procedures to look this way? When, at the end of it, they are promised a better life and better treatment from other people the higher up they sit on the scale of desirability?

It would be wonderful if women didn't feel the need to go to extreme meaures just to posture their bodies in a "desirable enough" light, and could show up to work wearing no make-up without being told they're "looking a bit rough". But people still expect different levels of prettiness and desirability from women, depending on where they already sit in society's desirability hierarchy. We cannot shame people for using the tools around them to make their life easier and receive basic human respect. Whether that's a make-up brush or a razor, why would you want someone to suffer even more under the guise of having "superior feminist morals", when they're just trying to survive? We can't shame people for taking the steps and precautions that are expected of them just to be seen and heard in this messed-up world.

Different women experience different levels of expectation from society to perform femininity. Marginalized women such as trans women, fat women and women of colour don't always have the privilege of "rejecting beauty standards" such as growing out their armpit hair, or even wearing their natural hair that grows on their head. Because of our racist and fatphobic beauty standards

– which subconsciously enforce our "preferences" when dating, hiring people, choosing friends – the way they are perceived just by existing in this world in their natural state is seen as "undesirable" and they are treated as "less than" already, *without* actively rebelling against gender norms.

Performing femininity and desirability isn't always a choice for marginalized women, it's often an act of survival.

Have you ever thought about how differently you would experience the world if your appearance changed?

If you cut off all your hair, if you stopped wearing make-up – would it make you feel *invisible? Or maybe you have already experienced this!* Think about your own privileges within these pre-set standards of desirability, and consider how they might have afforded you unearned benefits ahead of other people.

For example, one of my desirability privileges is that my whiteness is *already* perceived as "friendly" and "approachable" before I've even had a chance to speak or show people who I am. This subconsciously encourages people to open up to me and talk to me, enabling me more opportunities than women of colour, and Black women in particular, who are so often perceived initially as "intimidating" and "unapproachable" before people get to know them.

SHAVING

I stopped shaving my body the second I realized the reason I did it wasn't anything to do with my own discomfort, but was in fact entirely due to patriarchal brainwashing leading me to believe that my body hair was unattractive. I was fed up of being told that I

should be repulsed by something that was part of my own body. I wanted to love my body, not hate her. As a survivor of sexual assault, I hate being told what to do with my body, and growing out my hair was a subtle and personal act of resistance and self-care that was instrumental to my healing process. It restored some of my autonomy, knowing that men and capitalism had no control over my body hair. *Fuck your overpriced pink razors, I'm gonna be a hairy bitch now!*

Growing out my armpit hair was a very intentional and conscious decision, but being able to grow out my body hair is in fact, a privilege. Sure, it's not viewed as desirable by the standards of the male gaze – most people still think it's repulsive and you will be shamed for it regardless of your race. But being able to grow out your body hair without facing *additional* discrimination is a privilege afforded only to thin, cisgender, white women like me. Because even with my armpit hair (which I can shave off any time I want) I will *still* be viewed as "desirable". And in a sexist, racist, capitalist society which places its value of women on their appearance and whether or not they're visually pleasing, having "natural" desirability is a *privilege* because you're more likely to be afforded opportunities, just for existing in the body that you do. I will still be viewed as "feminine" whether I shave or not, a privilege that not all trans women, fat women and women of colour have.

People compliment the hairs on my legs all the time, but complimenting people's body hair for being "blonde" and "fair" is a compliment at the *expense* of women of colour, whose body hair grows naturally much thicker and darker, often across their

arms, upper lip, legs and brows. A lot of women of colour and trans women don't have the privilege of "forgetting" to shave or just letting it grow out, because they're constantly expected to show up in ways that people like me aren't to "prove" and perform femininity, in order to be met with the same respect I'm afforded as a woman, even when I don't do these things.

The ability to defiantly resist is only afforded to those who are already privileged enough not to be ostracized if they do so.

I don't know many trans women who grow out their leg or armpit hair, because they are held by society to much higher standards of "proving" their gender than cisgender women like myself are. Trans women don't owe it to anyone to perform their gender in a way that is hyper-feminine – but we must acknowledge that we live in a society that expects them to nonetheless, just as we expect women of colour to. There are double standards associated with our acceptance of body hair that cannot be ignored, and conversations around hair positivity need to centre around the voices of those whose bodies are most marginalized by society's expectations in the first place. It does not make you morally superior to grow out your body hair, and you're not any *less* of a feminist for shaving. Because let's face it, *life is easier when we shave*. Do what you want with your body hair! But remember that real change doesn't start until the people in the margins of our society are liberated and able to make the same decisions (without discrimination) that thin, non-disabled, cisgender, white people can already make.

RE-BRAINWASH YOURSELF!

To begin unpacking your own desirability bias and "preferences", you can start by listening to, learning from and respecting people you're *not* attracted to. If the content you consume is exclusively delivered to you by people you find palatable enough, thin enough, white enough, "nice" enough to listen to (*aka* – me) – then I'm going ask you to level up and challenge your *bland taste buds*. If you're only willing to hear one side of any argument, then you are fundamentally limiting your scope and ability to see beyond and above your own viewpoint.

Work on diversifying the content you consume. If you're constantly consuming and accessing the same media and content delivered by the same people – how are you ever going to open your mind to other people's perspectives, if it's always filtered through a privileged gaze?

Unfortunately, straight white men dominate our media, and the media shapes our culture, so we have to make a conscious effort to break out of this cycle – it doesn't just happen.

Take action now. Read books by Black folks. Follow fat, disabled and trans people on Instagram.

We spend our whole lives being bombarded with *hetrifying* love stories, so follow queer couples on social media! Listen to podcasts created by people of colour on your way to work or, if you work from home, listen while you're working.

Up until now we have been bombarded with the same stories that either make us subconsciously hate ourselves or hate others. It's time to change the narrative, and the power lies in your hands. Consume diverse content. Reinvigorate those tired taste buds.

YOU ARE THE LOVE
OF YOUR OWN LIFE

One of the most radical acts under capitalism is to simply love yourself. Especially if the love you have cultivated for yourself is enough to fill you, without the need for romantic love to feel validated.

I often think how much the younger version of myself would have hated the person I am today. If the 14-year-old me had heard me saying the words "I am the love of my own life", I would have thought of myself as conceited, self-obsessed, selfish. In fact, dear reader, you might be doing the very same right now.

The truth is that for a lot of people, it can be extremely uncomfortable to say nice, positive things about ourselves. For women in particular, we're taught that this makes us "vain". So when we hear others exude confidence it can remind us that we don't really value ourselves as highly as we should. We're forced to see the reality that deep down we don't really love ourselves, and to cope we might try to tear down the people who do. But with a shift in perspective, we're able to work on the relationship we have with ourselves, and stop projecting our hurt onto others.

We live in a world that profits from our insecurities, and it's often the patriarchal system that tells us we must settle for love, a kind of love that often lands us in the most emotionally

debilitating and coercive relationships. Deciding that you deserve better is radical as hell, because you are actively going against centuries of social brainwashing and oppression; you are telling the world that you see through its bullshit. That you acknowledge it wants you to exist in one way (marry the first man to "sweep you off your feet" and have his kids...), but instead choosing to go your own way and make up your own damn rules.

A new person is born in the moment you say to yourself, for the first time, "I deserve better".

LIFE IS TOO SHORT NOT TO LOVE THE SHIT OUT OF YOURSELF

Most of the time, "self-love" and "self-care" are sold in a way that just further perpetuates the need for women to be constantly desirable and palatable. *Treat yourself! Buy this face mask! Pamper this! Pamper that! Shave your legs! Moisturize them! We're not trying to sell you anything – this is about you! It's self-care!* I don't know about you, but years of internalizing the messages about how women's bodies should look and the rigorous standards they're held to made me feel as though my body didn't belong to me – this *cannot* be eradicated by a stranger placing hot stones on my back. This kind of "self-love" takes me right back to square one – valuing myself based on the desirability of my face and body. While making myself up and feeling cute does bring me joy, it's only a temporary fix. It's instant short-term validation. It's a distraction.

I haven't learnt to love myself through a spa treatment, body wax or facial. Oh no. In fact, the journey started when, at 14, I lay in the middle of the busy park that all the girls from my school

frequented, and tried my hardest not to give a shit what any of them thought of me. I told myself that if I could lie there and listen to *one song*, without caring what anyone thought, I could do literally *anything*. This was a big moment. My biggest fear was being judged by others and I needed to conquer it. I was in an emotionally abusive co-dependent friendship with a girl who later isolated me from our entire friendship group after hearing rumours about my eating disorder. I had a lot of social anxiety. I feared looking like "a loner". I feared having to discover who I was, outside of serving someone else's needs – because the truth was I had no idea. But because I'd been exiled from their friendship group, I was left with no choice but to find out.

So, lying in that park alone scared me, but it also unshackled me from living a life restricted by other people's perceptions. It's not their bullying that "made me the person I am today", but my own resilience that enabled me to adapt. I had stepped out of my comfort zone, and entered the world of *living*. I had a taste of what my life could look like if I truly denounced the need to be liked. If I hadn't made the decision to lie in that park, I wouldn't be writing this book today, because I wouldn't have found the courage to unapologetically voice my opinions. The ability to do so was born in that moment. *Full stop.*

Think about something you wish you could do. What is it that's stopping you from pursuing it? Do you hate the thought of being alone in public, or is it the perception you imagine *other people* have about you being alone? It sure was the latter for me. The idea of being out on my own? Bliss. The idea of people seeing me out on my own? Hell. I *revelled* in my alone time, but I was afraid of being

judged by others for being on my own.

It's the same principle with my body hair. I'd been shaving it religiously for years, only to realize that the sight of it wasn't making *me* feel uncomfortable, it was the thought of making others feel uncomfortable if *they* saw it. My fear of others' opinions on the hair that grows naturally out of my body (just as men's hair, which society deems socially acceptable, does) made me take a razor blade to my armpit and leg hair every single week.

Making these autonomous decisions is tricky because it means breaking life-long habits. It can be further complicated by your identity intersections in society, and by your class privilege, ability privilege, sexuality privilege, race privilege, cisgender privilege etc. Our lives as women are already so restricted in terms of what we can and can't do because of the safety measures we're forced to take – living our lives constantly vigilant and compromising our comfort for our safety in public – so why should we self-impose *further* limitations around what we can and can't do?

The truth is that no one is ever looking at you and thinking "what the hell are they doing on their own?". Most of the time the things we are insecure about aren't about *our* dislike towards them, but what we think *others* will think when they see us. But no one actually cares because they are wrapped up in their own dialogue. If you've never done it before, promise me you will take yourself on a date. Don't take your laptop, don't use your phone, go completely and entirely alone with no other purpose than to simply eat, drink and watch the world go by. Life is far too short to be waiting around for someone to ask you. You are the love of your own life, so act accordingly and take your damn self out.

PATRIARCHY WANTS YOU TO SETTLE. DON'T.

As a society, we have such an odd way of pitching and positioning single women. The way we talk to women approaching their thirties is often as though at any given moment, if they don't couple up, they might actually *combust*. We tell them that they need to get their skates on and pressure them to act soon while they're "young and beautiful". The fact that a lot of women fear being single has a lot to do with the language surrounding relationships. We talk of women being the "last one on the shelf", people in couples talk of their partners as their "other half" as though being single means they're incomplete. Heteronormativity has truly fucked up so many of us, to the point where we would rather be in a toxic relationship than have no relationship at all. Heteronormativity wants women to *settle*.

Heteronormativity has convinced us all that being single is some kind of tragic fate, as though we have been thrust unwillingly into a state of "waiting for the next relationship", a state which we must get ourselves out of immediately. I changed the way I viewed being single when I flipped my perspective. I realized it was a *choice*. You're choosing to be single, you also might have turned down some people since your last relationship, and that in itself is you actively deciding that you'd rather be *on your own* than settle for less than you deserve. You have set your standards and, by staying single, you're sticking to them. You have decided that you deserve quality treatment (whatever that means to you) and anything that does not seek to add value to your life doesn't deserve a place in it. Simple! Knowing what you'd want from a partner, new friend or even your career can be so powerful.

Because when situations and people which *do not* align with what you want and need present themselves, they can be intentionally avoided.

They're just a distraction.

Carry on, as you were.

"Single" doesn't mean "waiting for someone".

Choosing to be single is an autonomous choice, and a lot of men fear autonomous women and gender non-conforming people. It reminds them that we have other purposes on this planet than to serve them. Women who don't have kids are called "selfish" and made to feel that their life is a waste. Women in heterosexual relationships who earn more than their partners are labelled "controlling" or "bossy". Women who reject sexual advances are called "frigid", yet that same accuser will call a woman who enjoys casual sex a "slut". When people make autonomous decisions about their bodies and their lifestyles they are met with a whole spectrum of resistance and this is particularly true for marginalized people. Anything that deviates from the narrative society has written for and about you is shamed and unaccepted.

In a society that punishes you either way, the only option is to do what makes you happy.

Do you prioritize your romantic life over your own mental health, friendships and the relationship you have with yourself?

If you could stop worrying about romantic love altogether, what would you be able to achieve with this new, enormous resource of energy?

STOP SETTLING FOR CRUMBS, YOU DESERVE THE WHOLE DAMN CAKE

What are crumbs, you ask?

Crumbs are the *audaciously* small tokens and gestures that people throw us, in order to keep us under the illusion that they deserve a place in our lives – despite bringing very little (or no) value to it. We often allow this kind of behaviour because our low self-esteem leads us to believe that this is the kind of love we deserve, and over time it becomes normalized to us. When we continue to accept crumbs from someone, it enables them to dip back into our lives when they're bored and treat us like a doormat because technically, no one "closed the door".

Crumbs can be any of the following:

- Text messages.
- Liking your Instagram pictures.
- Replying/reacting to your Instagram stories.
- Hitting you up randomly with a "wyd" text.
- Saying things out of the blue that they know will fluff your ego.
- Dropping back in after a period of ghosting. (When they're running low on self-esteem, you're their "hit" to make themselves feel better.)

You'll notice most of the "interactions" I have listed occur online. That's because someone who gives you crumbs doesn't have any *actual* time for you IRL. Because, *surprise!* They don't value you. It's hard to hear I know, but they value only what you can do for their own ego. If they do "make time" for you, you can bet it will *always* be when it suits them. During late hours, when they're

bored, or when the person who makes them work for attention isn't texting *them* back. They know they can rely on you to boost them back up. This person will keep throwing you just enough crumbs to make sure they never lose that spot in your life, but not enough to the point of actually spending any of their energy, investing any of their time or reciprocating the energy you give so freely and instinctively to them.

The *moment* someone shows the audacity of trying to keep you around for an exchange of crumbs, communicate to them that you want the whole cake (i.e. that you want to be taken out on a proper date/build a relationship with this person). If they say they can't give it to you, that they're not ready to give you the cake, or they promise they can give you the cake at a later date, leave them where they're at and move the hell on.

Promise yourself to stop buying into people's potential. You're not a start-up investor.

When you settle for crumbs it sends a message to that person that that's all you think you deserve. They know that they can get away with doing the absolute bare minimum to have a seat at your table. That they can come and go as they please – for the price of their mere *attention*. They've become a parasite, and you're their host.

But my love, you deserve better than that. Depending on our "desirability", our childhood experiences, friendships, relationships and trauma, we all received different messages about what kind of love we deserve. Please know that no matter what you've been told to believe about yourself, the toxic kind of love you've learned to "accept", or whatever it is that society has

brainwashed you into believing, you are *no one's* fucking doormat. You are not a source of energy for others to take. This is *your* table, *you* set the standards and *you* choose who gets a seat. Start turning away people who have the audacity to show up in your life with crumbs, because crumbs can't feed you. Find someone who brings you a whole cake.

Learning how to love yourself, to avoid relying on other people's validation to make you feel whole, is the *key* to not settling. *You've got to learn to make the cake yourself.* Because when you already have a delicious fucking cake, the idea of someone else's crumbs and settling for a mediocre love that leaves you starving ceases to be tempting. You must live your life as if no one is ever going to make you a cake. Don't sit around waiting for someone to give you the cake. Bake it yourself. Start from scratch. Add ingredients to the cake. Experiment with your cake. Write your name all over the cake in vanilla fucking frosting and cover it in your favourite toppings. This is how you refuse to settle for less than you deserve! You ensure that you have everything you could possibly need, *supplied to and from yourself*.

The process of being single and dating to me is very much like making my own cake. Refining the recipe, learning which ingredients I like the taste of and which spoil the mix, so that I will always have enough to fill and satisfy my desires without the aid of someone else.

You are the love of your own life.

Make your own cake.

REFUSE TO FIND COMFORT IN OTHER WOMEN'S FLAWS

Internalized misogyny is the silent, insidious killer of progress, and when it shows up in our lives it can make us act out in all kinds of ugly ways.

First things first, "flaws" aren't really there. Flaws are man-made.

And yes, I mean **man**-made.

They're seeds planted in our minds by manipulative power systems, to make us feel so insecure that we buy products that promise we will become more acceptable, more desirable and physically attractive. The beauty standards of our society are racist, fatphobic, ageist and quite frankly, confusing. The things you feel most insecure about in your body are more than likely a direct result of capitalism because it works very hard to make sure that you will never feel enough without the aid of its products. The models we see promoting these products and advertising this image of perceived flawlessness don't even look like that themselves. Their skin has been airbrushed, their bodies manipulated and their features enhanced. In a lot of cases, Black

women's skin is lightened and their features dramatically altered in post-production to make them look more European and perpetuate the colonial idea that whiteness equates with beauty.

As a result of the rigorous beauty standards that we are so harshly held up against, we inevitably find a disturbing amount of comfort in tearing down women who reflect our insecurities *back to us*. We are distracted by capitalism's ability to manipulate us because it is hidden in the promise of "becoming more beautiful", which actually just means becoming more desirable for male consumption. This creates a toxic competitiveness among women, in a pursuit to fill the void caused by insecurities and these toxic standards of beauty. Capitalism profits from the insecurities it is responsible for creating in the first place and it is entirely exploitative. How can we happily exist in a world which is built on systems that seek to tear us down?

The internalized misogynist will tell you that women shouldn't do "certain things" because of this sexist narrative that society has laid out for us. I used to hate the *shit* out of hot, confident bisexual women. Why? Because I was jealous that they got to live their truth! It was so threatening and frightening to my heteronormative understanding of my own sexuality. Seeing them thrive and dating whoever they wanted – how *dare* they. They were everything I wanted to be but couldn't, because I had placed limitations on my own sexuality due to this internalized biphobia. Instead of dealing with the fact that I was bisexual myself, I projected the shame around my sexuality onto the women who were confident enough to own it. I hated that these women were living the life I wanted, but I didn't realize that

was the reason until I had finally accepted and embraced my own sexuality.

Once you heal your insecurities, get to the root of where they originate and identify the parts of yourself that you're ashamed of, you reframe your perspective of others and open the door to a wonderful thing called *empathy*.

It is through years of retraining that I have minimized the power internalized misogyny has over my thoughts. I realized that judging other women is usually just a quick way to get out of dealing with the things we dislike about *ourselves*. We seek comfort in other women's perceived "flaws" in an attempt to avoid addressing our own insecurities. The things that have been planted in our minds keep us competing with each other, preventing us from growing and discovering our innate divine power – this is the patriarchy's main goal.

Every time you catch yourself critiquing a woman on the choices she makes – who she sleeps with, how she dresses – sit in it. Reflect. What is it about her that makes you feel so uncomfortable? Perhaps she actually just reminds you of yourself, or the parts of yourself that you are ashamed of. Or perhaps she's the very person you *want to be*. Sometimes we dislike women simply because they're making the bold choices that we are too afraid to make ourselves, the choices that society has made us feel are wrong or shameful because they go against the patriarchal narrative. Or perhaps you're like me – you actually just really fancy her and need to go *ask her out*.

Ask yourself why you think this way, instead of just accepting it. Reprogramme your patriarchal brainwashing.

The girl you're jealous and hateful of isn't a "bitch", your **internalized misogynist** is.

EXAMPLES OF INTERNALIZED MISOGYNY

Here are some key examples of what internalized misogyny looks like, and how to handle it when she rocks up in your brain:

You find yourself saying "I'm not like the other girls."

What are you implying the other girls "are like"? If you are reinforcing stereotypes that women are "bitchy" or "full of drama" and the message that you are the exception, darling, *you are not.* You're literally sat there bitching like the "rest of us"!

Stereotypes sit at the bottom of a pyramid and they fuel the bigger problems at the top, such as gendered physical violence towards women (it sounds dramatic, but it isn't). Don't perpetuate the cycle. Stop trying to please men by shaming other women. It's never worked.

You constantly find ways to tear down successful women.

We truly despise people who remind us of the parts of our lives we wish we were thriving in, but aren't. "Who the hell does she think she is?!" "I don't like her. I can't put my finger on it, I just don't." "She's so annoying. She's changed since she's become successful." Be careful not to fall into the habit of tearing down other women to make yourself feel better. The satisfaction will wear off and you'll be back facing those unaddressed insecurities that you

need to work on. That's on you, it's your responsibility. Leave her alone, let her shine!

No, you don't have to like *all* women – don't put that pressure on yourself. You do not have to uplift, empower or make friends with someone who you don't get on with just because they are a woman. But, depending on our privileges, there are times where we should be giving up space to further marginalized women. The key is to learn to recognize whether the problem is actually her, or if it's your own insecurities. Take note of the things that make you want to tear her down. A big old red flag to look out for is if you catch yourself taking even a *little* comfort in her pain, unhappiness or "bad days" on social media. If seeing someone's low moments eases your anxiety and makes you feel like you're "winning", work on it. For example, are you jealous that she's running a thriving business? Go home, write a list of all the things that bring you joy and figure out ways to start making a profit. Are you pissed that she has lots of cool, like-minded friends? My love, use the internet! Follow pages with your interests and try to build an online community of like-minded people that you could potentially meet IRL. Is she always pulling incredible looks, is her make-up on point? Start watching those YouTube tutorials! Does the fact that she has a similar style irritate you? Great minds think alike, why not pitch a collaboration instead?

If we can learn to view other women as opportunities for inspiration and empowerment in our own lives and realize that there is enough room for all of us to be happy, the relationships and bonds we form together will be unstoppable.

You hate your partner's ex.

Being in a relationship with someone who has an ex-girlfriend is the perfect opportunity to wrestle through our internalized misogyny. This is possibly the most heightened that our internalized hatred of other women can ever become. Why? Because we literally put ourselves in an imaginary competition with our partner's ex. And with social media being a 24/7 accessible window into someone's life you'll probably catch yourself stalking her for hours on end – comparing yourself to every single aspect of her life or, worse yet, actively trying to seek out flaws for temporary relief to make yourself feel better. It's awful, and it's ugly. If it gets to the point where you start picking fights with your partner over her because of your insecurities, try to remember that it's not on them, this is on you.

But don't worry, you've got this. It's a great opportunity for you to work on strengthening the love you have for yourself and, as a result, other women! It's so easy to blame other women because, well – everyone blames women! We are constantly used as the scapegoats to justify other people's actions. So maybe you need to also question whether the reason you're so worried about their ex is because the person you're with just isn't the one for you. As soon as I dumped my ex all the petty resentment I'd built up towards the women he had a history with dissipated. It made me realize that he was the problem all along. He brought out a nasty jealous aspect in me, and life's too short to be around people who make you feel like you need to compete for their attention. If that's the case, just dump them. Don't waste time with someone who doesn't acknowledge that you are walking divinity, darling.

You say "she's a slut."
Or is she actually just getting on with her life and exercising her right to bodily autonomy? Regardless, it's none of your business.

Ask yourself if you would say the same thing about a man. These pernicious stereotypes are largely saved for women, and when we bad-mouth other women for expressing their sexuality, we feed into the narrative that women have no agency over their bodies. Whatever women choose to do with their sex lives, it's never your business. In a society that turns women into objects, who are you to judge people that find empowerment in the very narrative that tries to demean their human existence?

You say "she's so bossy and intimidating!"
When a woman asserts her boundaries and says "no" to things, she's not being bossy. She is doing exactly what she has to do to protect her energy and GET. SHIT. DONE. Ask yourself this question: "is she intimida*ting*, or am I intimida*ted*?"

Is she bossy or is she just acting outside of the submissive-woman stereotype that society has convinced you she needs to be – instruction-taking, submissive, docile? Women are socialized to constantly pander to the needs of everyone else but themselves, and even if we do decide to take care of ourselves, we are encouraged to do it in the form of "retail therapy" or "facials", still pandering to our appearance instead of our mental health, giving money to products that tell us we exist only to be desired and good looking.

Respect women who set firm boundaries, don't see it as a threat. She's worked really fucking hard to get to a point in her

life where she has decided to choose her happiness over people-pleasing. When you see women acting outside of their gendered stereotype, remind yourself that there is no one way to be a woman, and tell your internalized misogynist to shut the hell up! Gender roles are socially constructed and we are allowed to behave as closely, or as far away from them, as we wish.

Maybe she's a "bitch", or maybe her ability to unapologetically set boundaries makes you uncomfortable, because it forces you to acknowledge that you are a doormat to everyone in your life.

...Maybe.

You judge other women on their appearance.
When my own judgemental thoughts show up, I flip them around and say the opposite. Empower others instead of judging them – practising empathy can change the world. For example:

- You see a woman walking down the street in a miniskirt and your immediate thought is that she should be dressing "more carefully". Flip it around; instead say, "Her clothes aren't the problem, the problem is rapists and their predatorial behaviour towards women's bodies."

- You see an older woman rocking a tight dress she ordered off ASOS in the club and your first thought is, "Bloody hell! She's too old for that!" Flip it around: instead say, "Wow, in spite of ageism and the sexist idea that women past a certain age shouldn't love and flaunt their bodies, this woman decided to just go for it anyway! What a fucking legend."

- You see a woman who covers herself up (for religious or non-religious purposes, neither of which are your business) and

your immediate assumption is that she must be "prudish" and "unempowered". Flip it around: instead say, "Different things empower different people – there is no one way to be a woman. Women are multifaceted human beings capable of being more than one thing at the same time."

- You either treat butch women/masc women with less respect or you make remarks about their appearance because of their lack of femininity. Flip it around: instead say "Wow, in spite of the expectation for women to constantly cater their appearance to the male gaze and the privileges that come with this, these butch ICONS are choosing to express their gender in a way that feels most authentic to themselves."

- You judge or pity divorced women. Flip it around: think to yourself, "Divorced women are actually iconic. They successfully escaped a situation in which they were unhappily trapped. I hope I have the courage to do the same if I ever find myself in a similar situation."

- You make comments on Black women's hair, or use words such as "bossy" or "aggressive" to describe Black women in power. Any unsolicited comments on how Black women choose to live their life or carry themselves is both misogynistic and racist. Full stop.

I could go on forever. But when it comes to judging other people, ask yourself if what they are doing is affecting you. If it isn't, we must learn to move the fuck on with our lives. If we want to battle through internalized sexism and our constant urge to judge women on their appearance, we must be willing to challenge it when it pops up in our minds.

You judge other women who pay for aesthetic procedures.
In a society that affords *undeserved* privileges once you reflect its beauty standards, we cannot judge, criticize or shame other women who pay to make themselves look this way. The media is saturated with hyper-feminine, objectifying portrayals of female characters. We can't take the effect and make it the cause. Wouldn't it be incredible if we lived in a world where women didn't feel the need to adhere to sexist beauty standards, and go under the knife? You're goddamn right it would. But that world doesn't yet exist. Which is why we must fight to make it exist, instead of blaming women for trying to thrive within the framework that is currently on offer.

You find yourself saying things like "she looks good for her age".
Ageism is a heavily gendered issue. It seems that any woman past the age of 25 has an urgency placed on her by society to rush and find a husband before she's "old, wrinkly and infertile".

When was the last time you heard of a man exclaiming that he *must* find a bride before he gets old and grey? When have you heard a man get excited over finding a bride? Men are taught to put themselves first, and it's about time we were encouraged to do the same. There is a societal time limit placed on women, as our value as human beings is tied to our physical "beauty". The older we get, the less valuable we are to society. We are deemed worthless if we are neither fertile nor "beautiful" in the eyes of the male gaze (see page 67). The next time you find yourself commenting on a woman in relation to her appearance, abilities or God forbid her fertility, stop. Ask yourself if you would say the same thing about a man.

If you have ever caught yourself thinking or experiencing these thoughts, I suggest you give these intrusive thoughts a name. And then tell them that they don't belong in your mind or life, because they're ruining your relationship with other women.

MAYBE IT'S TENSION, MAYBE YOU'RE PROJECTING

Do you ever find yourself talking about other people to your friends and create this whole narrative in your head that they "have it in for you" or that they hate you? Even though you've had little or no communication with this person at all?

Well, they don't hate you!

You just hate *yourself!*

The only person "judging you" is yourself. They are holding a mirror up to your insecurities, and you can't handle it. Stop shaming that girl in the club who's dancing her tits off in a short dress and living her best life – and go bloody join her! Stop assuming that confident women hate *you* just because they love *themselves*. She isn't your competition, this isn't about her, it's about you. It's a big thing to be able to admit your own shortcomings and actively work to stop your own insecurities affecting other people. Try as often as possible to operate your thoughts from a non-judgemental place, and catch yourself when you do this. We all do it, we're all human.

Your character is not to be judged by the mistakes you make – but your ability to hold yourself accountable, interrogate your actions and come back with the correct behaviour.

HOW SHOULD YOU DEAL WITH WOMEN WHO INFLICT MISOGYNY ONTO *YOU*?

It can be incredibly hard to experience the wrath of the patriarchy at the hands of another woman, but remember that *everyone* internalizes sexism. We all live in the same society and internalize the same messages. The way they are treating you is not a reflection of you or your character, but of their own internal dialogue. If someone is judging you, try to empathize with them instead. Try to see that they are hurting and that the way they are talking to you is a projection of how they feel about themselves.

Let's break the cycle of abuse.

MAYBE IT'S A GIRL CRUSH, MAYBE YOU'RE QUEER

Your queer feelings are entirely valid.

Let me start with a bit of clarification, as the words we use and the way we use them matter. It's important to know that the word "queer" has its roots in the history of queer *oppression,* not empowerment. It originally came into use in the 16th century and meant "strange" or "odd", then began to be used as an insult in the early 19th century towards people who were believed to be in same-sex relationships. However, LGBTQ+ activists in the 1980s reclaimed the word "queer" as a political statement to self-describe their identity.

Today, "queer" is widely used as a term for sexual orientation and gender identities that are not heterosexual or cisgender. If you're not straight, or you don't identify with the same gender you were assigned at birth, you may wish to self-identify as queer. Queer covers all sorts of sexual/gender identities, such as bisexual, asexual, non-binary and gender-fluid. It's important to remember that queerness is political. Equally, some people still remember times when "queer" was used as a slur against them and because of this they don't feel comfortable adopting this label – which is valid too.

Rigid and archaic gender roles got in the way of living my truth for so long. Any time I vocalized my feelings for women and other genders as a closeted bisexual, I was often told that these feelings were just a "fantasy", and a fantasy only to be carried out for the entertainment of men. On top of this there was a lot of internalized homophobia to work through, which for me sounded in my head like, "You don't look queer enough" or "You've never been with a woman, how do you even know?" But I did know.

I knew because at times I'd had to think about women during sex.

I knew because I had fallen in love with my female friends.

I knew because my thoughts about women were recurring, and the thought of being in a relationship with a woman made me feel at home with myself.

I had always been compelled towards women – but I was *also* attracted to men and people of other genders. So what was it that stopped me from owning my queerness?

One night after consuming a lot of cocktails I ended up crying to my best friend, confessing my feelings for women, and that this was a whole part of my identity that I felt I hadn't given air to (I'm very dramatic). I was in a toxic long-term relationship with a man at the time, and I hadn't allowed the queer in me to *breathe*. As a femme, I never saw another person who looked like me dating girls in the media or in real life, and I thought that people who felt the way I felt *and* looked the way I looked, didn't exist. My limited, stereotypical understanding of queerness stopped me from validating my feelings. It's even harder for marginalized

people (Black queer people, disabled queer people etc) to come to terms with their sexuality, as they're less likely to see themselves represented in the media at all, let alone *also* represented as queer. But the way you express yourself, how you dress and your other intersecting identities have no direct correlation with your sexuality. I learned to see these things as they exist individually, and outside of the binary. Who says queer *doesn't* look me? Why can't I date women and *also* have a feminine gender expression? I realized that by invalidating my own queerness, I was stereotyping other queer people. There is no one way to look, present or act queer. If you are queer, then you look queer.

The stereotypes about the gay community and how being queer is "supposed to look" (i.e. a traditionally masculine gender expression, short hair) stopped me from embracing an enormous part of my identity, and a lot of this has to do with an oversaturation of heteronormativity (encouragement of heterosexuality and gender roles), and therefore *lack* of queer representation in the media and public domain. My understanding of bisexuality was simple – it didn't exist. I never forget a friend once telling me, "My dad says bisexuals don't exist. You'll never meet a woman over 30 who still identifies as bisexual, it's a phase." As a teenager who was having an internal battle between my multifaceted self, and what the world, my peers and family expected of me as a young woman – I internalized this message, shamed away my feelings for women, put them into a box in my head and labelled it "Girl Crushes". The term "Girl Crush" was really just my creative way of saying "no homo". I was deeply embarrassed to admit my feelings for women.

If you're one of those people who talks of having girl crushes or says to their friends, "If I was gay I'd totally date her", have you ever considered that sexuality exists on a spectrum, and that you don't have to be "one or the other"? If you say you'd like to date her, maybe it means you actually just *want to date her*?! Bisexuality/ pansexuality by definition means "attraction to more than one gender"; if you are attracted to other genders as well – this doesn't take away your attraction to men! I decided in my late teens to unpack the "Girl Crush" box of shame in my head and address that these were just genuine crushes I had on other human beings.

The shame that women have surrounding sex is the same shame that seeps into our desire to be with other genders, because we are taught that our bodies exist and belong to the male gaze – so having feelings for other women is bound to confuse us.

For most women for our entire lives it has been imprinted, stamped, engraved and carved into our brains that one day we will marry a man and have his children. Dating and falling in love with a woman goes against this narrative. *How dare we be with anyone but a cis man?*

Heterosexuality is the fairy tale we are spoon-fed growing up. We see it on our TV screens, learn about it in sex-ed and read about it in our bedtime stories. I like to call this relentless bombardment, quite simply, *hetrifying.* Something so straight and heteronormative, that it makes you feel *hetrified.* There's a lot of debate about casting "too many" queer roles in the media in fear that it will brainwash the youth. But queer representation in the media isn't going to brainwash your child, boomer. Because heteronormativity *already has.*

There's a hierarchy of how relationships are viewed in our society, and ones that are comprised of cisgender, white, non-disabled, heterosexual, middle-class, married people with kids are placed on top. But here's the beautiful thing about being queer – by just existing outside of these definitions you get to throw society's restrictive rulebook out of the window. You get to write your own damn script and you can freestyle, as there is far less pressure to adhere to any previous ideas of romance, sex and "relationship progression".

THE FEMALE GAZE

"The influence of heteronormativity and the male gaze was so strong that I, someone who has fallen intensely in love with multiple women, felt like an imposter calling myself bisexual."
– Ramona Marquez

As a bisexual woman, I questioned why it is that I don't enjoy viewing women in the same way that men do. Why I don't get instantly turned on from looking at hyper-sexualized images of women, and why it doesn't arouse me. I realized that it's because portraying women in this light wasn't created to suit my sexual needs. It wasn't created to satiate my queer sexual desires. Women are positioned as sexual objects of desire in the media to feed the appetite of the *male* gaze (see page 67).

When the dominant narrative of our society is heteronormative, I doubted my bisexuality because the only way I'd ever been taught that you can love women was to sexualize them. Which is far from the truth – healthy relationships are

not built on objectifying or fetishizing your partner but on respecting them and seeing them as full human beings, not sexual ornaments.

The sexualization of women's bodies is so normalized, it made me question whether loving a woman outside of her objectification was valid enough. That if I didn't objectify women and talk about them the way cis men did, that I couldn't possibly be queer.

How **hetrifying**.

Despite my desire to date, have sex and be in relationships with women and non-binary people, I just didn't look at them in the same way that cis men did. I didn't see pictures of naked women and react in the same way that men did. I saw myself in them, I saw a multifaceted human being.

The idea of going to a strip club or gawking at a woman in a night club didn't elicit the same response from me as it did from my male counterparts. For some queer women it will, and that's also valid! But I didn't have the language to describe the capacity in which I felt I was attracted to women, because it wasn't in the way men typically did. But the reason most queer people don't instantly view women in a sexual way is because we're not viewing them through the lens of the heterosexual male gaze. We're not holding their beauty to the same standards. We look at them instead through our own gaze – the queer gaze.

Give yourself room to work through your desires and what influences them – what is it about the people you're attracted to that makes you like them? Whether you identify as part of the

LGBTQ+ community or not, here are some questions you can use to reflect on your own life, and what role heteronormativity has played in your identity:

- In what ways has heteronormativity had an effect on your life? In what ways have the unwritten rules of how your gender "should behave" affected your everyday life, your body language, who you date, your self-expression and sex life?
- Do you assume people's sexuality or gender just by looking at them?
- Have you shamed away *your* queer feelings?

LOVE SEX, HATE SEXISM

... AND NEVER FAKE AN ORGASM

It takes two to tango, so why is a woman's pleasure in heterosexual relationships still so rarely prioritized?

Why are we shamed for even implying that we enjoy sex, that we are able to take pleasure into our own hands through masturbation, and have multiple sexual partners the same way cis het men do? What kind of a message does it send to young women if we teach them that only men are supposed to enjoy sex? Are we just supposed to be a mere counterpart to their orgasm? Where does *our* pleasure fit into this? When our sex education is saturated with heteronormativity and lacking in discussion surrounding consent, it's not surprising that so many people are subject to unnecessary trauma during their first time. *Because not one of us knows what the fuck we're doing.*

Sex positivity is about bodily autonomy and your intrinsic right to express your sexuality however you desire. Whether that's by learning what you like and practising on yourself, meeting someone on Tinder for a commitment-free hook up, or deciding that sex isn't a priority for you at all because you've discovered that you're on the asexual spectrum – all of these are ways of expressing your sexuality. Because guess what? There *is* no norm.

Everything in life is experienced on a spectrum, everything you feel is valid and exists. It's also allowed to *fluctuate* up and down, depending on where you are in life and what you need at that stage. You need only to listen to yourself and your needs in order to discover what sex means for you, and what that looks like. Just make sure that you're doing what feels right for you.

LEARN TO FUCK YOURSELF

I found out how to make myself orgasm from a very young age, and it takes me *seconds* now. I remember worrying that I'd walk downstairs afterwards and there would be a mark on my face, some kind of "universally acknowledged indicator" that would reveal what I had been up to, and my parents would find out. The guilt was actually so unbearable I once dramatically burst into my mum's room to confess to her that I had "tingly feelings" watching the scene with Rizzo and Kenickie getting it on in the car in *Grease*.

The reason I'm sharing my discovery of masturbation with you is because I want to destigmatize it. I can't even count the amount of times I heard (and believed) that "girls don't like sex" as I was growing up. You hear something repeated enough times, it starts to feel like the truth. When we are taught we "don't like sex", all that teaches us about our sexuality and our bodies is that they are to be reserved exclusively for men, and *their* sexual desires. It normalizes us as "passive participants" in sex, and not people who enjoy the experience equally. This narrative is particularly harmful for queer women and often prevents them coming out until later in life. A lot of queer women have sex with men because the normalization of discomfort is internalized so deeply,

they don't think for a second that the reason they feel this way could be because they're simply not attracted to men. After all, "girls just don't like sex".

It is socially acceptable for boys to watch porn and masturbate, so much so that they can discuss this without shame in social circles and conversations. Can you imagine talking about the "fantastic wank" you had in front of your friends as a teen, without feeling the guilt of societal slut-shaming heavy in your chest as you say it?

When we exist in a culture where women are ashamed to talk about their own pleasure this only further perpetuates the harmful narrative that we don't enjoy sex, because we are too ashamed to talk about it. The first time I spoke about masturbation with my friends felt akin to coming out, it was genuinely liberating and gave me a deep sense of validation, completely abandoning the internal shame I had been harbouring for years. It's not always easy to talk about taboo subjects but once we openly discuss them, the stigma-sting is taken out of them and they become a place of free discussion and exploration.

Not to be dramatic, but my first vibrator changed my mother-fucking life. I bought it a few months after I was sexually assaulted. I didn't want what happened to me to take away the relationship I had spent years rebuilding with my body – I wanted to regain control. I wanted to reclaim my damn pussy and I wanted to love her again. I was fed up with feeling like she belonged to everyone but *herself.* I've had up to ten orgasms in one go with my vibrator, and buying this sex toy enabled me to claim back my body for myself. The body I had been shamed into hiding and reserving

for men, and their gaze, my entire life. I once told an ex-boyfriend about the amazing orgasm I gave myself with a shower head using *that* setting, and he gave me the silent treatment for an hour. He eventually told me it was because it made him feel useless. Do you see how backwards it is? That it's "normal" for me to perform sexual acts for his gaze and in his company, but the moment I take control over *my own body* without a man in the room I am forced into some kind of "self-reflection treatment" and made to feel shame?

It is imperative that we normalize masturbation for *all* women. Because if we can normalize masturbation we also normalize female sexuality and, with that, be viewed as people who enjoy sex too as opposed to passive objects to have sex *with*.

STOP JUDGING PEOPLE ON THEIR SEX LIVES

When it comes to having casual sex, a lot of us have been taught to think that "we don't wanna seem like *that* kind of girl, maybe we should hold out a little longer". Which is all part of the internalized misogynist trying to stop us living our best lives, while simultaneously slut-shaming other women who *are* that girl. There's nothing wrong with that girl, we love her! She is inside all of us. We want to see *more* women feel as though they are able to command their own lives and choose what's right for them, without feeling an ounce of guilt or shame.

A woman should have the right to choose what she wants for herself, just as men have the right to.

As a queer woman, dating people of different genders made me realize that casual sex can be a shame-free, beautiful,

communicative and reciprocal experience as opposed to a *performance,* because it is free of gender roles. There's no cis het male gaze present during queer sex (at least, not a *physical* male gaze present). You step out of "performance" mode, and enter "do whatever the fuck feels good" mode. It's also taught me that encounters without shame do exist. Know that you should never have to settle for anything less than *reciprocal, enthusiastic* and *consensual* sex. Yes, "even if it's casual"! This is the bare minimum. Not only that, *it is the law.*

If you have a vulva, buy yourself a hand mirror and promise me you will get to know it. It's frightening how many people have never seen their own genitals, or have no idea what they look like. A lot of the shame we have around pleasuring ourselves, or even prioritizing our orgasms during intercourse is because we don't even know what it looks like, let alone how to work it. So we don't bother communicating with our partner since we've been shamed into not acknowledging our need for pleasure. One of the most empowering things you can do for yourself is to reconnect with your body and learn about its anatomy. If there's one thing I wish I had had hammered into my skull as a young girl, it's that your body is *yours* and it belongs to *you* first, before it belongs to anyone else or their sexual desires.

If you have a clitoris, get to know it.

Neglecting the one part of your body that is designed exclusively to give you pleasure is an intentional effect of years living under patriarchy.

Rub your clit as a private act of resistance.

IF IT'S NOT A 'FUCK YES', IT'S A 'NO'

A lot of people are reluctant to ask for consent because they feel like asking "kills the mood". But you know what *really* kills the mood?

Sexually assaulting someone.

Taking a second to consider your partner and check that you're both on the same page shows maturity, high levels of emotional intelligence and respect for their boundaries. A person who's considerate of their partner's pleasure and consistently checks in to make sure they're comfortable exhibits high self-awareness. And that means that they're more likely to be aware of their *own* needs and desires. Self-awareness is, personally, such a turn on. What's hotter than a person who knows what they want and can confidently communicate these desires to their partner? Asking for consent is not only the law, it's very sexy.

Here are a few ways to ask for consent:
- "Do you like that?"
- "Can I take these off?"
- "Is this okay?"

- "Do you mind if we switch positions?"
- "Can I go down on you?"
- "How do you like it?"
- "Are you sure you feel ready for this, or would you prefer if we carried on kissing?"
- "Please know that you can say 'no' at any time."

Consent is mandatory, it is the law and it's not some form of flirting or foreplay. However, it can seamlessly fit into intercourse. Why not ask to remove their underwear while you're already kissing their neck, or whisper it in their ear? Or ask if they'd like to fuck you between kissing? It doesn't have to be the awkward and robotic script that it's been made out to be (unless that's your thing – we don't kink-shame in this family).

"WE DON'T HAVE TO DO ANYTHING TONIGHT"

As a survivor of sexual assault, nothing makes me feel more comfortable than when the person I'm intimate with creates an environment where I feel like at any point, I could say "no". When people ask and check in this takes the onus off you to have to *tell anyone* to stop. It relieves you of the pressure to feel like you have to do things you don't want to do.

For a lot of women who are used to a lifetime of being objectified, nothing feels sexier than safety. This means being able to do whatever you want in the bedroom, knowing that if you wanted it to stop *they would stop*. We don't empower women to feel that they're able to reject sexual advances. Rape culture is maintained because we fear the consequences of simply saying "no" in the first place.

We don't empower women to set boundaries and most of the

time – unless they are *consciously* and *intentionally* implemented – they're non-existent. The worst part is that for most women, it usually takes the most traumatic experiences to force them to learn what "boundaries" and "red flags" are in the first place, when they learn about them in therapy or through a conscious decision to heal *after* sexual trauma. One of the main reasons I'm writing this book is to introduce these concepts to people, hopefully before they have to learn the hard way like I did.

Many times people consent to sexual activity because they fear what might happen if they reject the advances. But part of dismantling rape culture starts with encouraging women to set and *hold* boundaries, no matter the reaction they might receive. This is not victim blaming as the responsibility not to rape lies solely with the rapist. But if women aren't feeling empowered enough to say "no" in the first place, we will continue to foster a culture of coercion and "blurred lines". Consent is the only way to have sex. If there's no direct exchange of consent, it's rape:

- If you ask for consent and they hesitate or take a little longer to answer, reassure them by saying something like, "It's okay if you don't, would you prefer we just did x instead?"
- If they don't answer with a clear and enthusiastic "yes", it's a "no".
- "I'm tired" doesn't mean "convince me".
- "No" doesn't mean "keep asking *until I say 'yes'*".
- "No" is the most definable boundary in the world. There are no "blurred lines" when it comes to consent.

If it's not a "fuck yes", it's a "no".

THE RULES OF SEX

- Ask before doing something or progressing.
- Make sure if you want to have intercourse that your partner wants to have it with you too.
- If someone is asleep, unconscious, drunk or high they cannot consent to sex.
- Check in with someone every time you start a new sexual activity, whether that's going from oral sex to penetrative sex, or even switching up positions.
- Consenting to sex in the past or being in a relationship with someone does not automatically mean consent for the future. E.g. if Sam says he wants to have sex with Sally, but when it gets to it after 30 mins of foreplay Sam says he's too tired, Sally is not then entitled to have sex with Sam because he previously agreed. Sam can change his mind. He does not owe Sally sex.

SEX AND ALCOHOL

Sex is an experience, not a performance.

When it comes to sex we often feel this need to perform, and we all have our share of body insecurities and self-esteem issues. Whether it's your first time with a new partner or you don't really know what you're doing, it can feel a bit awkward and you might want a drink to take the edge off your anxiety and kick in a bit of confidence. But if you're drinking, remember that *drunk consent is not consent,* so sex with drunk consent is technically rape. If you're feeling anxious about wanting to sleep with someone or have low self-esteem when it comes to your body, you might want to try communicating this with your partner. It might seem scary

to open up and be vulnerable, but there is nothing worse than waking up feeling confused and not being able to remember what happened "the night before".

SET SEX BOUNDARIES

We all have different boundaries, but it's important to check in and make sure that you're not slipping into disruptive habits. Here are a few red flags to memorize for the bedroom.

They refuse to wear a condom.
Dump them *on site.* If someone doesn't respect your body and the consequences you might face for the sake of their quick, short burst of pleasure –they've GOT to go. I mean it. If someone removes a condom during sex without your consent, this is sexual assault. There are plenty of people out there who are willing to respect your boundaries – people ignoring your desires and safety is not normal, it's just been *normalized.*

They're only nice to you during sex, or after you've had sex.
They're using you – you're not a person to them, you're an object. Also, if they're only hitting you up late hours, it means you're their quick-fix and they only want you when they're bored. Casual sex is totally fine, and you should be able to enjoy it without shame just like men. But if you feel like deep down you're accepting casual sex from someone when you want a relationship with them (settling for crumbs when you want the cake, see page 24), then stop settling for it. Reserve that energy for someone who can meet *all* of your needs, because it's what you deserve.

They call you demeaning names.
Unless previously agreed that these names are okay for you, if someone starts calling you "slut", "whore" or "bitch" during intercourse, this is a big red flag. Especially if you've asked them to stop and they continue, it shows an enormous lack of respect towards you and your body. Do they even see a person at all, if this is what they're calling you? Most of this behaviour is re-enactment of porn and it's not a sign of an emotionally healthy partner.

They perform *any* sexual act on you without asking first.
Sure, sex can flow naturally and we can pay attention to the person's body language to see where things might be going. But consenting to a kiss doesn't mean you're consenting to oral sex. Just because you're having a nice big sloppy snog on the sofa, it doesn't mean it automatically "leads to fingering" because "That wAs the VibE". Ask first.

They use guilt and shame.
If someone makes you feel guilty for not having sex, or for not liking the same things as they do, or uses your insecurities to make you do things – *goodbye*.

They expect you to pay for emergency contraception.
Despite both people being equally responsible for unsafe and unprotected sex, people with vaginas are always expected to pay the price for birth control, emergency contraception and morning-after pills because it's seen as "our problem". This person doesn't care about you enough if they can't share the responsibility.

OTHER FORMS OF CONSENT

The truth is that respecting people's boundaries goes beyond sex. An ex-boyfriend once drew on my body and took pictures of me while I was sleeping. Men physically put their hands on my waist to "gesture" that I need to move out of the way, instead of politely asking me to move. Women treat me like an agony aunt and come up to me in the toilets, off-loading their trauma, expecting me to offer therapy in the cubicle.

Our relationship with boundaries, whether setting our own or respecting other people's, depends on our upbringing and re-enacting our earliest relationships from childhood out of our subconscious. While this *explains* our lack of boundaries, it does not *excuse* them. We must actively work to rewrite what we know to develop healthier boundaries, so we're able to maintain better relationships with others and ourselves.

Here are some ways people violate boundaries:

- Asking someone to do something more than once, after they've already said "no". By doing this, you push the person into feeling pressured to compromise their boundaries to please *you* and betray *themselves*.
- Entering someone's bedroom without permission (depending on the relationship).
- Taking pictures of people without consent (when someone is sleeping, walking on the street and so on).
- Borrowing people's things without asking first.
- Reading people's phones without their consent.
- Touching people's hair without consent.

- Offloading your problems onto friends, strangers or people on the internet without checking in first.
- Helping someone without checking first to see if they want help.
- Giving unsolicited advice to someone who never asked for it.
- Pursuing someone who has given adequate signals that they're not interested or that the relationship has ended.
- Outing you to someone as LGBTQ+.

Having a lack of boundaries doesn't just mean you're more susceptible to accept things that aren't good for you, it also means you're likely to exhibit toxic behaviours yourself that could cause harm to someone else.

Here are some signs that you have unhealthy boundaries:
- You touch other people without asking.
- You go against your own personal beliefs and values to please other people. E.g. taking drugs on a night out because everyone else is doing it, even though you don't usually do them.
- You fall in love with someone new very quickly. It's a sign that you're seeking validation and need something to make you feel whole. You can't love someone you know nothing about.
- You offload your life story and your traumas to someone when you first meet them.
- You find it hard to say "no".
- You give as much as you can for the sake of giving without asking for reciprocity, because you struggle to communicate your desires.

- You subconsciously seek partners who need fixing and healing.
- You constantly excuse someone's mistreatment of you – "they're only like this when they're drunk."
- You protect people who are doing damage to you.

I had to end a toxic relationship when I realized the treatment I had allowed and accepted from someone meant that my boundaries had become non-existent. I had allowed my boundaries to be worn down over years to accept a love that was less than I deserved. The ultimate act of self-love is to know when to walk away from a toxic relationship and, although hard, this is you actively practising self-care, self-preservation and self-worth. It's a powerful agent in your steps towards self-empowerment. It's you choosing yourself and acknowledging that there is a way out of repetitively involving yourself with the same toxic people.

It's never too late to set boundaries with people in your life, and if they don't respect them?

I hope you love yourself enough to walk away.

"WHAT DID SHE EXPECT, GOING OUT LIKE THAT?"

It shouldn't be normalized to experience discomfort, fear or aggression during intercourse. It shouldn't be normalized to just "roll over" and "give in" when we have already said "no", or said nothing at all.

Maybe one day I'll "tell my story", but I don't think details are important. For now, I'll just say "me too" and use this space in my book to pass on the lessons I had to learn the hard way. However, I'm afraid there's one thing I *can't* teach you – I can't teach you how to avoid sexual assault. It's not something anyone can avoid by taking protective measures, because sexual assault is *never* your fault.

Having "uncomfortable sex" is often accepted as a necessary introduction to womanhood. This sense of "girls not enjoying sex" makes uncomfortable experiences feel *normal*. That is why the term "rape culture" is used – it describes the social culture fostered that normalizes and justifies rape:

- Rape culture is reinforced by idioms such as "boys will be boys" to excuse men's actions, and insinuating that there are "blurred lines" when it comes to consent with lyrics such as "I know you want it".

- Rape jokes are used as a form of male bonding.
- The fact America elected a president who bragged about sexual assault and "grabbing women by the pussy", and spoke out about the fact that he could do this because of his position of power.
- The preventative measures we are encouraged to take to "avoid" being raped, instead of taking measures to stop people from raping in the first place. These include "covering up", buying rape whistles, never walking home alone, moving to an apartment where you can see who's at the door before they can see you, carrying keys between your fingers, not making eye contact with men, packing an extra layer for the walk home, lying about where you live, choosing shoes in case you need to run, avoiding jewellery that makes a noise and draws attention, deciding who you give your number to, making sure there's something in your purse to fight off an attacker.
- Rapists rarely ever see a prison cell. In 2018, only 1.7 per cent of rape allegations in the UK resulted in a charge.

ONE OF THE "NICE GUYS", HUH?

Rape culture spins the narrative that "nice guys" don't rape. But they do. In fact, 90 per cent of all rape perpetrators are already known to the victim*.

These "monsters" we imagine and spend our entire lives being taught to avoid in the streets and in dark alleyways, *are actually already in our lives*. They have sisters, mothers, friends,

* Glasgow University study, reported on BBC Online, "Sex attack victims usually know attacker, says new study", 1 March 2018. https://www.bbc. co.uk/news/uk-scot-land-43128350

careers, families – you might even share a bed with them. This harmful narrative – that we need to "look out" for rapists on the streets, when they're usually already in our lives – is an enormous component of rape culture, and puts the onus back on the victim to take every precaution to "prevent" rape happening to them.

Our society has an innate urge to use women as scapegoats, in an attempt to justify rapists' actions and avoid holding them accountable. One of the most harmful types of misogyny is the belief that victims who speak up about their experience of sexual assault have in one way or another "asked for it". But let's be clear here, it is physically impossible to "ask" for rape.

The way people interrogate rape victims is almost like a checklist:

- "Did you definitely say 'no'?"
- "Did you push them off?"
- "Did you not lead them on?"

If you didn't take all the preventative measures, they believe it's your fault.

There's a world of silence that's quietly and insidiously enabling a system of sexual violence to continue. However, cracks are beginning to show. Through #MeToo, the movement founded by Tarana Burke, more victims are speaking up. Slowly our secret, disgusting reality is being revealed. An *apocalypse* would occur if every single person guilty of rape and sexual assault was outed – society would not know how to cope with the realization that so many people they know and love are complicit and have committed rape. In fact rape is so normalized, people don't even realize they themselves have committed it.

In order for it to stop, there need to be open conversations *now* about what has happened, how we can stop it from happening again, and making it clear from a young age what does and doesn't constitute consent. Because when sexual violence isn't openly discussed, it becomes normalized. And when it becomes normalized, it becomes accepted. And when something becomes accepted, it leads to the culture we are currently living in where people are being raped and committing rape – without even knowing that it's rape. When something is normalized it forces the victim to question if what happened to them is a big enough deal to speak out against. But it is a big deal. Sexual assault is always a big deal.

There was no one I felt I could talk to about my experiences of sexual assault, until I founded my online community and quickly realized I wasn't the only one. We live in a society that functions on our silence and we are immersed in a culture that perpetuates it. If we dare to speak out, we unravel years of carefully woven structures that are in place to protect men and their actions, which they are still yet to be held accountable for. This is why victims don't speak out. *Everything* is stacked against them, encouraging them to keep their mouths shut.

SOME THINGS AREN'T NORMAL, THEY HAVE BEEN *NORMALIZED*. THERE'S A DIFFERENCE.

When we have said that we're "too tired", when we have asked them to "stop", when we haven't given communicative consent. It's easy to blame rape culture on the fact that consent is only recently being discussed in *some* schools, but what kind of a

person still wants to have sex with someone who has verbally expressed disinterest, *whether they were taught consent or not*? Someone who looks uncomfortable, someone who is scared. Yes, consent is not taught in many schools, but the problem is also deeply entrenched because of the extreme and violent types of porn that are widely available to (not to mention produced by and for) men. We live in a culture that breeds and encourages toxic masculinity, at the expense of women and our bodies. But I'm bored of blaming the "culture" that rapists were raised in. We forget that *people* are culture – and it's time to hold these people accountable for their actions.

STOP INTERROGATING RAPE VICTIMS

If someone talks to you about their experience of rape or sexual assault, never ask them why they didn't report it. Never ask them why they're not fighting it. Treat people as experts on their own experiences and believe them. Blaming the victim is a system that men created to avoid accountability, and it's a system that they can perpetuate happily with legal backing. In the US, only 2 per cent of reported rapists ever see a prison cell (and if you include unreported accounts it's actually 0.5 per cent of rapists that go to jail)[*].

It's the only crime where we interrogate the victim as though they were the perpetrator. You wouldn't ask someone who was robbed, "Why didn't you fight the attacker off?" because as a society we understand and respect that other people's personal possessions are not for others to take without consent. *Duh!* But

[*] "The Criminal Justice System: Statistics", Rape, Abuse & Incest National Network website, https://www.rainn.org/statistics/criminal-justice-system

when it comes to sexual assault, we still believe that women's bodies exist solely for male consumption. If she's walking home late at night? *It's up for grabs.* It's almost seen as a right that because she was out there "in the wild", that a man can come along and use her body for his pleasure. Because "that's what women's bodies are for". Think about that for a second. We respect other people's wallets and materialistic possessions, and treat reports of theft to the police more seriously than we do the rape of women's *bodies*. Bodies which are now traumatized, violated and carrying the heavy burden of silence for the rest of their lives.

Things to avoid saying to a victim of sexual assault:
- "Did you definitely say 'no'?"
- "What were you wearing?"
- "Did you try to fight them off?"
- "Why haven't you reported it? They can't get away with this."
- "Be careful about reporting it, you could ruin their career."
- "Are you *sure* it was rape?"
- "Did they definitely hear you say 'no'?"
- "If there was no struggle, how is it rape?"
- "Somebody really wanted to have sex with *you*?"

Affirming things to say to a victim of sexual assault:
- "Thank you for trusting me with your story."
- "I believe you."
- "How can I support you?"
- "However you handle this situation, I support your decision."
- "You didn't deserve this."

People are so quick to ask survivors why we didn't report it, without realizing there are systems and people *every step of the way* to ensure this never happens – *even* when we do try to reach out. The system fails so many rape victims every single day. Rape is the most under-reported crime and, after my experience, I finally understood why. I told a person of authority the day after it happened, and they encouraged me not to report it because they said, "I'd think twice, this might ruin his career". Months later, I decided I would ignore this advice and I got the courage up to report it anyway. I went to a sexual assault clinic to talk to the police and they told me there was "nothing they could do", and that there would be "no point" in reporting it.

So, I'm writing to you to be the person I needed in that moment. To remind you that if you're worried the truth might "destroy a man's career" – fuck his career. That's on him, *he* should have thought about that before he to tried to take what didn't belong to him.

Go ahead.

I believe you.

WOMEN DO NOT EXIST TO SATISFY THE MALE GAZE

"A man in a room full of women is ecstatic. A woman in a room full of men is terrified." – Unknown

It costs *more* to be a woman, in the same world where we are paid substantially *less* than men, and we're tricked into believing that "splitting the bill" is the route to equality? Regardless of your gender, this should make your blood *boil*. This eye-opening perspective on patriarchy was first introduced to me by author and activist Chidera Eggerue, and I haven't stopped thinking about it since.

Here are just a few examples of the tax we end up paying for misogyny, and how the presence of the heterosexual male gaze limits our experience in this society:

- We choose our route home based not on efficiency, but on which route is less likely to have men lurking around who will potentially harass or assault us.
- We give a fake name and number to a guy who won't leave us alone in a bar, or say that we have a boyfriend, because we fear what he might do if we just say "no".
- The money we spend on preventative measures "just in case" – rape alarms, pepper spray, tasers.

- The money we spend on contraceptive measures and morning-after pills. The responsibility of keeping sex safe and correcting mistakes is almost always down to us.
- Queer women are not able to show displays of affection in public because of the sexualized response from men, and the unwanted attention it attracts. Girl-on-girl love in public is always assumed to be a "performance" for men.
- Constant vigilance and awareness of our every move in public, to avoid giving men "the wrong idea". Everything is calculated, we rarely get to just *be*.
- The resources of time, energy and money that go into being "presentable" (*aka* "desirable" by racist, fatphobic, transphobic beauty standards) so that we are met with basic human respect – shaving our bodies (our razors are also more expensive than men's), applying our make-up and doing our hair in the mornings. Of course, this is all a choice. No one is *forcing a razor to our armpits*. But if we don't pay in *prettiness*, we just end up paying the price of unsolicited comments about our appearance. We cannot win either way. This is made particularly hard for marginalized women who occupy bodies that are deemed less "desirable".
- The money we spend on cars and taxis to get home safely, when men and people with male-passing privilege have the option to just walk home or take the bus, because they don't fear being attacked or raped.
- If we do decide to walk home, we often pack an extra layer or an entire different outfit to wear to and from the club/bar.
- Any applied effort to our appearance as women is considered

an "invitation" for men to start talking to us, so we often dress ourselves down or cover ourselves up to avoid receiving unsolicited remarks. Even then, if this isn't effective we police our body language.

- The male gaze has sexualized and objectified our bodies so much that they have been shamed of their inherent functions. People who have periods hide sanitary products and feel ashamed when we need to go use the bathroom.

- Getting off public transport early because we have been harassed/made to feel uncomfortable, as the threat of someone following us home if we get off at our *actual* destination is very real.

- The embarrassment/shame of breastfeeding in public.

The consequences of the male gaze are exhausting and expensive. We spend money and energy keeping ourselves safe from men, and yet still – we are paid less than them.

"The male gaze" is a term coined by Laura Mulvey to describe the way women are portrayed as objects in the media. It has insidiously permeated every facet of our lives and identities. From the films we watch, all the way down to our craving for its validation.

Everyday rituals –applying make-up, shaving, doing our hair and choosing our clothes – are all decisions subconsciously filtered through the desires of the all-powerful male gaze.

These are the rituals that we are expected to perform in order to be treated with the same respect men are afforded for showing up just as they are.

It all comes down to our bodies and our desirability, no matter

what we do, who we are or what we achieve. The expectation to perform prettiness is laid on even thicker again, for marginalized women (see page 13).

BODY POLITICS

I have a very confusing relationship with my body; there are times when I feel as though it doesn't belong to me. Equally, there are times when I genuinely do not feel safe in my *own body*. How awful is that? The one place you're supposed to call home feels like an unsafe place to inhabit. Maybe it's because the perceptions I have about it are based on hetero male gaze standards and not my own, or because I have been sexually assaulted, or because my body is groped and chucked around at night clubs, or because cisgender men dominate conversations about what we are afforded in reproductive rights. Or it could be because the shape of my stomach has been discussed between hundreds of men in comment sections on YouTube. There really are a multitude of experiences and events I can pinpoint in my life where I have been told, with words or with non-consensual actions, that my body doesn't belong to me. The world thinks it's up for grabs, depending on my choice of clothing, and up for discussion just by *existing*.

What kind of a relationship are we expected to have with our own bodies, if not a conflictual one, when we are socialized to believe that they exist for male consumption? We are taught that men are entitled to our bodies so much so that we are blamed for being assaulted because of our choice of clothing, but *still* expected to present in a way which is desirable enough for them to look at, in order to receive respect and acknowledgement. The

mixed messages we receive about our bodies make us incredibly vulnerable to capitalism, as we are encouraged to buy solutions to fix our biological "flaws". It becomes easier to navigate our distorted perceptions of our bodies once we understand that a lot of the normalized beauty rituals are a direct result of capitalism, and not actual human "flaws". Flaws don't exist. Capitalism exists. But because capitalism exists within most human interactions in society, these flaws have been legitimized. The insecurity of body hair on women, for example, was a seed planted by male advertisers in 1915, because they realized they could make money selling razors to women. Before then women didn't shave, it simply wasn't something we felt insecure about. But they planted the seed of insecurity and then filled a gap in the market. Voilà! We've been trained and socialized to be disgusted by our own bodies for male consumption and capitalist profit.

THE MALE GAZE ACTIVELY LIMITS AND RESTRICTS YOUR EXPERIENCE ON THIS PLANET

The limitations that the male gaze have imposed on my life is one of the main reasons that I go to therapy. It manifests as an anxiety in my stomach and makes me short of breath when I walk down the street at night, and at times during the day too. Additionally, there's the anxiety for my safety that comes when I'm on a date with another woman. When you're on a queer date there's no "seizing the moment" that you get on hetero dates. When it comes to kissing or any form of affection, you scan the room for lurking eyes, and have to check that it's a safe place for you and the person you're with. I also tend to check in with the person I'm on a date with to see

if it's okay, because for obvious reasons, some people aren't as comfortable being visibly queer. There have been times when I wanted to kiss someone in public, and if wasn't specifically at a queer safe space or there were people around, we've had to kill the moment and go somewhere else, just to kiss.

Being visibly queer in the UK isn't as safe as the media will have you believe, and when you're two queer girls on a date, you can bet that at least once you'll be approached by men who think you're just friends. In my experience, it's even worse when I'm a date with another femme. *After all, what could two girls possibly be doing looking like that at a bar, if not for male attention?* I have literally been holding the hand of a girl at a bar and had a man come over trying to chat her up, and when I told him we were on a date he went, "Don't worry, that's hot! I'm into that!"

I swear to God – you cut men and they *bleed* audacity.

HOW MUCH OF MY FEMININITY IS WHO I TRULY AM, AND HOW MUCH OF IT IS A PRODUCT OF PATRIARCHAL BRAINWASHING TO EXIST FOR MALE CONSUMPTION?

When I think about who *Florence Given* really is, I imagine that she's locked deep inside of me, hidden, waiting to be revealed. She's feeling suffocated, wrapped inside the false narratives that have told her who she should be since birth.

I can't help but wonder how much of my identity is just a product of layers and layers of coping mechanisms developed to survive years of emotional abuse, toxic relationships and existing under patriarchy. How are we ever supposed to know who we really are if our entire existence has already been decided for us the moment we were assigned male or female genders at birth? If

we have been brainwashed to identify with our assigned binary gender? How are we supposed to know how much of our identity is constructed or real, and how much of it is a product of the society we were brought up in? Where we have been force-fed heteronormative narratives, and taught to present ourselves in a way that is both desirable and acceptable?

The ways our decisions are controlled by the male gaze are so insidious, we don't even realize it affects the daily choices we make.

In the eyes of society, the more feminine we are the more "desirable" we are, and having desirability as a woman gives us the privilege of being acknowledged and visible. Not to mention that "femininity" as a standard anyway is measured by a woman's proximity to whiteness and Eurocentric features. Our collective idea of "pretty" in the first place is inherently racist. We know that in theory we could turn up to work without make-up – no one's *forcing* us to wear make-up to work. But we know that we are treated better if we do. The cultural narrative is so strong that even as women we internalize it, and it says that if women are not desirable nor able to satisfy men, we are worthless. This is why most of us have such low self-esteem and fucking *hate* ourselves – because we are not living out our most authentic lives.

There are so many ways that we bear the consequences of patriarchy, and what's frustrating is that we are expected to show up in a way that pleases men just to exist in this world and to be treated with the respect we deserve. This costs money. Capitalism turns us all into objects of desire yet also expects us to pay the price to fit into this accepted vision, without questioning if that version of us aligns with our *own* desires. Never are we asked about how we

want to look for our own visual satisfaction. But as long as we don't question the status quo and continue not to challenge the ways patriarchy affects our lives, we prolong our collective suffering.

If you ever uncover parts of yourself that make you feel electric, in a world that thrives and evolves at the expense of your insecurities, please cherish them. These are *your* best bits. These are your best bits untouched by social conditioning. This is *your* identity. Be proud, for they are the parts of yourself that blossomed and survived despite years of assimilation. These parts make you iconic.

CENSORED

One of the most confusing messages we receive about our bodies is that we are told our worth is tied to our ability to be sexy and desirable, that our bodies are available to be used to sell products, that we are valuable when we pose naked, thin and airbrushed next to a perfume bottle to generate profit for large companies – but once we are seen to be harnessing that power for *ourselves*, once we are seen taking control of our own sexuality, we are a threat. A woman who has no shame of her sexuality, who knows her own power and is capable of harnessing her objectification for her own financial gain or self-empowerment is a threat to capitalism and the status quo. She's also an absolute fucking icon.

Enter, the all-powerful and insidious tool of violence – shame.

Shame does not want you to have autonomy over your own body, because society relies on having control over your body as its product – and products aren't supposed to feel "empowered", *they're products.* Shame is the tool that stops you from exploring self-pleasure and masturbation, because it means you might

realize you don't need men for sex. Shame exists in the form of calling women "bitchy" to make us feel embarrassed for speaking up and setting boundaries, keeping us vulnerable and easier to manipulate. Shame exists in the form of censoring women's nipples. Shame is weaponized to make sure we are never aware of our power. The world does not want you to wake up to the fact it is profiting from your subjugation, shame and insecurities. It doesn't want you to tap into your inherent power.

Not only are our bodies used as sites of objectification and breeding grounds for insecurities, but they are heavily sexualized, often before we've even hit puberty. I was branded "sexual" before I'd even had sex. Before I'd even done so much as kissed someone, I was told that my skirt length was distracting to male teachers, but that I couldn't wear trousers because they were for the boys. Equally, boys were unfairly not allowed to wear skirts. In other words, the message I was told and deeply internalized was: be desirable, be feminine, but not so much that men think of you in that way. Oh, and if you want to wear trousers, sorry sweetie but ThoSe arE FoR BoYs!

So much shame is embedded in our bodies. We are told to put ourselves on display for the gaze and financial profit of others, but *never* our own. In some places showing nipples is still illegal. Not all nipples of course! Just female nipples. But nipples aren't sexual. They're sexualized. A sexual gaze has been unwillingly thrust onto female nipples.

Inner observation task: Think about something you've always wanted to experiment with in your appearance, and ask yourself why you've never done it.

What parts of your self-expression feel like a routine?

What parts of the way you express yourself feel *electric*?

In what ways have you internalized the male gaze in your standards of beauty, and sexualized women's bodies?

For example, I'd spent the majority of my adolescence wearing body-tight clothing because I'd internalized the message that women are to be trophy-esque figures of desirability. My friends and I wore uncomfortable bodycon dresses we couldn't sit down in, paired with painfully high heels to parties. We taped our tits up to make them look bigger, wore shapewear under our dresses so we didn't have to spend the whole evening holding in our stomachs, and we had cuts on our legs from shaving close enough to remove every last prickle. I was wearing shapewear, shaving my legs, stuffing my bra and battling an eating disorder at 14 years old. I was taught that for women to be seen as desirable, we must experience discomfort. The phrase "Beauty is Pain" stuck with me – and it hurt me.

As soon as I came out as bisexual to my friends and family, I felt room to breathe. To question *everything*.

I asked myself for the first time who the hell I was even doing this painful performance for. Was I "doing it for me" or was I doing it be acknowledged by the male gaze?

The answer: **both.**

The influence of the male gaze was so strong I had mistaken it for my own idea of beauty. Shortly after I acknowledged this, I allowed myself to wear more baggy clothing – and I started to feel *electric* in my gender expression. I felt both sexy *and* comfortable,

something I didn't even know was possible.

I feel electric when I wear a suit, but I feel equally euphoric wearing nothing but a pair of leopard-print platforms. The difference is that now I view my gender expression as something that is constantly refining itself, finding ways to connect back to who I was before I was *told* to be someone else.

Think about what makes you feel alive in your body and jot down those moments as they rise in your life.

Outer observation task: The next time you watch a film, pay attention to how the female characters are positioned. Is the focus on the woman all about her desirability and curves? Does she even have much to say, or have they given all the important lines to the male actors? Does her character reinforce sexist stereotypes about women? Does she "risk everything for love" and won't stop talking about relationships? Google "examples of male gaze" and you will find plenty of ways women feel objectified for the way they look, as opposed to their male counterparts who are acknowledged for their achievements.

If you want to see the double-standard of how men and women are expected to show up in the world, just watch the dynamics of an awards show. You'll see women with three people holding up their dresses just to get on stage, targeted ads on Instagram will try to sell you diet tea so you can attain her "event-ready figure", but the backstage footage will show that she was in fact wrapped by a team of people in cling film just to get her into her corset. All the while, male attendees slip effortlessly into their suit and tie.

After all, men are invited to these events to win a trophy – not become one.

BEING HEARTBROKEN DOESN'T MAKE YOU A SHIT FEMINIST

There is a perception that being a feminist precludes being heartbroken.

That if you experience heartbreak, you are a failure.

First things first, in the middle of a heartbreak, it can be tough to differentiate between a general feeling of shittiness and more serious anxiety or depression. This advice is all based on things that have helped me in the past but please don't hesitate to seek therapy and medical advice if that's what you think you need. You know you better than anyone. However, we need to start with a little tough love:

- **Stop** trying to resuscitate a dead situation with a life-support machine powered only by your false hope; the hope that they're going to change their mind, realize your worth and choose you. Instead you're going to choose your damn self. We're not objects on a shelf waiting to be picked up by someone when they're "ready". *Fuck that.*

- **Stop** making them the main character in your life by appointing them as the "chooser"; give yourself some agency. You need to choose yourself. You're the main character, and they were merely a supporting role in Season 6 of the thrilling and unpredictable show that is your life. Move on to the next episode and leave them

behind, knowing that some powerful new plot development awaits you.

- **Stop** letting them have a stranglehold over your mind. You need to reclaim your energy for yourself. If that means unfollowing them on social media and asking your friends to hold you accountable for not mentioning them in conversations, then do what you have to do. When it comes to your peace, no boundary is "too dramatic". It's your life, and it needs you back at the wheel.

- **Stop** lying to yourself and telling other people that you're over it. If you're still mentioning their name three months later and manage to turn everything into a conversation about them, you're not over it. *And that's okay.* The first step to getting over it is admitting that you're not over it. It might still take months, or years, until you're actually over it. But the first step is to stop lying to yourself. Because how are you going to be in charge if you are selling yourself (and others) false narratives?

- **Stop** with the endless imaginary roadmap of possibilities, and different calculations that could have given the "situation" a different outcome. *What if I'd played it differently? What if it was the right love, but the wrong time, and eventually in the "end" they'll come back? What does it mean if they're still viewing my Instagram story? Do they want me back or are they just horny? Do I even want them back or am I just horny?* By asking yourself all these questions, you're still giving them the lead role in your life. They're still running the show. But they're not in your life – so why are you letting them dominate how you live?

Yearning, longing, being stuck in heartbreak.

That feeling of not being able to move on from, or past, someone means everything becomes about them. Somehow every conversation is about them, we check their social media because *damn* we feel like we have to scratch that itch when we're bored just to feel something (even if that something hurts).

We have to let go of a person or an event that hurt us many times. It's not just once.

Hour by hour and day by day we make incremental progress on our healing. Think of it as a pressure valve that slowly releases the intensity of our pain, with each release making it easier to withstand. When we relive the pain or cry ourselves to sleep, we aren't failing, we are progressing. Didn't mention their name when hanging out with friends? Progress! It's been a whole month since checking their social media? Progress!

It's like weaning ourselves off a drug. Because we will relapse. When we lose someone, a survival instinct kicks in and we find ways to keep them alive because it's too much to accept that it's over, that they will no longer exist in our lives. It's too much to accept and so we keep them alive in our memory and consciousness instead (by repeatedly watching their Instagram stories or scrolling through their pictures). But we can't properly grieve them and move on if we don't actually think it's over, that they are actually gone, and that they're dead to us. To get over it we need to admit that we're not over it, and that we're the ones keeping them alive by constantly talking about them. Not just to ourselves, but to the people in our lives. Say it out loud. *I am not over them.*

The illusions and stories we tell ourselves are there to protect us from experiencing the sharp end of really painful emotions and the impact of heartbreak (*aka* "they'll come back once they've slept around and realized they messed up").

But if we want to move on we need to have that conversation with ourselves, we need to accept the death of the illusion, grieve it, and grieve them. We can't move on and grieve something if we're still keeping it alive within us or if we're allowing the person in question to throw just enough crumbs our way to maintain access to us, without the commitment and the emotional engagement we might be after. Lowering our standards is never worth it, even for something "casual". We won't be fulfilled by what they have to offer and ultimately the rejection hurts twice as bad because really, we knew all along what we were getting ourselves into. We need to set a boundary with ourselves (stop checking their socials) or with the other person ("Please stop texting me, I need to move on").

Breaking up with someone has never been more fucking complicated. Depending on how long you were dating, how it ended, who did what and who messed up, or whether it was based on lifestyle differences, it's never been harder to erase a person completely out of your life the way you might have done a hundred years ago. I still follow a few of the people I've casually dated on Instagram, and they still follow me. There is an invisible tether between you. Some call it "orbiting" or "haunting" as this person never really exited your space, nor you theirs. They're always there, in the loop, watching your stories, or not watching them – which can make it worse if you have an anxious

attachment style: *Have they muted me? Should I mute them? Maybe I should block them so I can heal but that feels too "dramatic" since it ended wonderfully and it was just a series of dates?*

What to do?!

How do you get over someone when you're stuck in a loop of checking their social media and watching if they check yours too?

BREAKING UP WITH HEARTBREAK

Breakups are shit. In my experience, they're a lot easier to get over when the person was also a piece of shit as there's a sense of relief in being freed from them, because they never really deserved to be with you in the first place. (And the hardest part to come to terms with is that the people we choose to date are sometimes a reflection of how we feel about ourselves.)

But what about when they're not a piece of shit? And you still feel shit. Things just didn't work out because of "timing" or you were growing in separate directions? What do you do with all of this (now pointless) information you had stored about a person's life? When you can't look at anything without thinking of them? When the breakup ended on really fucking good terms so you can't even demonize them and slag them off to your mates to move on, because they really were a great person?

Here's a list of things I've done to get through heartbreak, some reminders, affirmations and a little more tough love:
- Make your Sad-Bitch playlist. Listen to music by women. In fact, connect with women, consume art by women and read

books by women. If it gets to a point where you get so fed up of your own bullshit that it leads you to the self-development section of Waterstones, good for you. Books are one of the best ways to invest in yourself, just know that reading one feminist book isn't going to stop you feeling pain when your heart is broken. But do read *Attached* by Amir Levine and Rachel Heller. It will teach you a lot about yourself, how you love, and what you can do to avoid seeking emotionally unavailable partners.

- Reclaim "your songs" by creating new, better memories with them. Dance around to them with a glass of wine in your bedroom, have great sex with someone new to them, belt them out on the street when you're making your way home from the pub with your friends, play them when the sun is shining. Whatever floats your boat. The point is to make sure that these are *your* songs now. Sometimes the universe will conspire and reclaim them for you. A song that reminded me of a really painful time in my life came on when I was in a wine bar two years later on my first date with a woman. It was a full circle moment. That song belonged to me again.

- Allow yourself to bawl your fucking eyes out if you need to. Cry in the bath tub. Sob in the supermarket. Wherever the sadness strikes, let it out.

- Talk about it with your friends until you've exhausted yourself.

- Stop letting the idea that they will come back rule your life. Allow yourself to grieve it, take as long as you need. The last thing you want to do is pretend you're over it when you're

not. But do not let the wallowing become self-indulgent. You do not need to live in sadness over unrequited love, it's not going to bring them back or change anything. In the words of Elizabeth Gilbert, "Grieve if you must, but grieve efficiently."

- Don't romanticize the "good times". Remember that you don't just date a person, you date their life. Recall the things they did that didn't align with your own values or the reasons things didn't work out. Write them down and refer to them when you pang. Stop editing out the parts of them that made the two of you incompatible.

- (Although it's tempting) don't trash-talk your ex. Discussing a person's actions and how they made you feel is one thing, but bad-mouthing our exes to others to protect our ego and feel like we "won" the breakup is another. If things ended well, there's no need to chat shit about them! People can usually see right through it too.

- If it was an abusive relationship, be prepared to find out that the person has started making stuff up about you to other people. When people can no longer control you, they try to control how others view you. Their worst nightmare is that you go around and tell people about what they did to you, so they discredit your voice by spreading lies. They may manage to turn a lot of people against you with their stories. But anyone who believes lies about you without hearing your side was already looking for a reason not to like you anyway. Accept the loss and move on with your life. For more support, Google "surviving a smear campaign".

- Remember that rejection is protection. If something didn't

work out, it's either because it wasn't meant for you, it wasn't meant for you now, or the universe has something better in store for you. How exciting!

- Use your heartbreak to spring into your new evolved self. Not being able to get out of bed because you're so heartbroken that life doesn't feel worth living doesn't make you a shit feminist. *Read that again.* I've been there, and I'll likely go there again. Because as long as you continue to date and interact with the world, heartbreak is almost inevitable. It is a part of life. But if you work through it properly, heartbreak will make you wiser and hotter.
- There's no time limit for healing. Remember, not being able to get over someone "even though it was ages ago" is okay.
- Stop playing down your desire for romance because you think it makes you a shit feminist! Has romantic love been so hyped up that it has become a distraction to keep people from focusing on themselves rather than on chasing external sources of validation? Yes. But does that mean we should have shame if we desire romance? No. Romance is wonderful. It just shouldn't be our everything. It is an addition.
- Consider staying single for a while. If you leap from relationship to relationship without healing or reflecting on what went wrong, it's just going to be the same person, same problems, different face.
- Especially for queer women, setting boundaries doesn't make you any less queer. If you don't want to stay friends with your ex because it's too painful, that's more than okay and no one should make you feel awkward about that. This also applies

to straight women too, everyone should feel able to own their boundaries.

- Choose peace, delete the burner Finsta account. Today. You don't need to know what they're up to. I promise you it will never "help you".

THE DIFFERENCE BETWEEN SELF-LOVE AND SELF-SABOTAGE

Let's call it out for what it is: texting your ex when you're horny even though they're not good for you is self-sabotage. Yet self-sabotage feels exciting. It feels thrilling in that moment. It offers temporary relief, but you *will* regret it; perhaps instantly, perhaps in a moment's time or even months later. Self-love on the other hand feels pretty fucking boring and means you have to abstain *a lot* in the moment because it involves fighting your urges and denying yourself pleasure, so that in the future you can enjoy a more sustained, long-term pleasure. Saying "no" to something today is a "yes" towards your future, as you won't have to deal with the consequences of the impulse that drove you to self-sabotage. How about when you get the urge to text your ex when you're horny, you take a breather and pick up your vibrator instead. Self-love decisions are typically hard to make, but they bring us peace.

The next time after a breakup when you fancy reaching out for "closure" from the person who's not good for you, remember that in the future you will pay for it, in the future you will be hurt, and you can't heal a broken heart if you keep wounding it. It needs to be left alone to heal and form stronger scar tissue.

WHY HEARTBREAK MAKES YOU HOTTER

It takes a lot of courage and strength to dare to love openly and follow your heart, while also allowing your painful past experiences to guide your standards and behaviour. Doesn't that sound like a fucking cool place to exist mentally?

It's all about balance. You have to learn to use the wisdom you acquired from your last heartbreak, while still remaining open to new experiences and people and not projecting your past pain onto them. It's a balancing act! Every heartbreak is a blessing in disguise. It teaches you what works for you and what doesn't. It has the power to transform and launch you off into a new version of yourself, a version more aware of who you are and what you need (and what you don't). A version that's closer to getting what you deserve.

WE NEED TO REFRAME THE WAY WE VIEW HEARTBREAK

Being upset because something didn't work out or someone didn't want us isn't something we should feel ashamed of. We don't need to take on the identity of being undesirable or rejected. Instead we can try to be proud of the fact that we saw something we wanted, and we gave it a fucking go. If we are brave and fearless in the pursuit of what we need and want, the universe will find a way to reward us or set us on another path. It just happens that sometimes, being set on the right path involves being dumped, so that we can find what really deserves us. Heartbreak, rejection and failed relationships are all proof that we went for something we wanted at the time and that we acted on our desire and instinct. That is something to be proud of.

Yet instead of recognizing this, we feel humiliated because our ego has a story about ourselves that says "a Bad Bitch like me doesn't cry over someone like that". But we do cry because Bad Bitches are also human. Deliciously complex and fragile, with a shit ton of insecurities, who are trying to live the fullest life possible.

Being heartbroken doesn't make you a shit feminist.

Heartbreak means you're living your life to the fullest. It means you're allowing yourself to experience the world fully. So what if you're crying over the person who ghosted you after what you thought was a wonderful date? That's a normal human response to someone leading you on and playing with your emotions! But you have got to pick yourself up, absorb the wisdom from that experience and try again with someone new (if you want to). You will gather some beautiful, some mundane and some soul-destroying life experiences, and that is what makes you a well-seasoned, fucking incredible human being.

FOR PERSPECTIVE

Healing is hard. If you have a tricky time appreciating the journey you've been on and how incredible it is that you're alive, I want you to imagine all the past versions of yourself, standing right in front of you. This could be:

- The person who was bullied in high school.
- The person who cried themselves to sleep.
- The one who drunk-sobbed in the toilets on a night out.
- The one who went through something so traumatic they thought life was broken beyond repair.
- The one who almost gave up on life completely.

Imagine all of the past versions of yourself, standing right in front of you. They are all smiling, looking back at you. They are so proud of you.

Because you *beat* what they were going through. You beat the things that tried to kill and destroy them. Because of *your* strength, you are still here in this present moment, in spite of what happened to those past versions of yourself.

They are grateful – you got all of them through this to be where you are today – alive.

This **brazen** book was created by

Editorial Director: Romilly Morgan
Senior Editor: Pauline Bache
Assistant Editor: Sarah Kyle
Deputy Art Director: Jaz Bahra
Senior Production Manager: Peter Hunt
Sales: Kevin Hawkins
Publicity and Marketing: Matt Grindon and Meg Brown